IMAGES
of America

SARASOTA
1940–2005

IMAGES
of America

SARASOTA
1940–2005

Amy A. Elder

Published by Arcadia Publishing
Charleston SC, Chicago IL, Portsmouth NH, San Francisco CA

Printed in Great Britain

Library of Congress Catalog Card Number: 2005926133

For all general information contact Arcadia Publishing at:
Telephone 843-853-2070
Fax 843-853-0044
E-mail sales@arcadiapublishing.com
For customer service and orders:
Toll-Free 1-888-313-2665

Visit us on the internet at http://www.arcadiapublishing.com

This book is dedicated to my husband.

Front cover: On the cover is a picture of the Sarasota Sun Debs taken in front of the Lido Casino in the 1950s. In the front row, second from right, is Barbara Bowers Ingles. (Photograph courtesy of Barbara Bowers Ingles.)

CONTENTS

ACKNOWLEDGMENTS

Without the help of Ann Shank and Mark Smith of the Sarasota County History Center, Diane and George I. "Pete" Esthus, Alice Cross, David Keane, Elizabeth Elder, Douglas Elder, and Mary Thayer, this book would not have been possible. Thank you to all. I would also like to thank my editors from Arcadia Publishing, Kelly Miltenberger, Jeanie Dela, Caroline Reed, Ruth Wishengrad, Gail Novak, Laurel Crump, Nancy Allen, Maryann Boehm, and Dori Goldfarb. Once again, I need to thank the many residents who donated pictures to the Sarasota County History Center.

INTRODUCTION

Sarasota, Florida, is a seaside resort city that has had a long and varied past. Prior to the arrival of Western Europeans, the area was populated by ancient Native Americans who left behind evidence of their habitation in the form of shell middens. Originally visited as early as 1539 by Hernando de Soto, the famous Spanish explorer, and later by migrant fishermen, permanent European settlements in the area did not take hold until the 19th century. Sarasota itself was just the southern half of Manatee County until it was separated in 1921. The area went through several phases of growth prior to 1940, many of which are covered in Images of America: *Sarasota*, the first book of this series. This includes the Seminole wars, early homesteaders, development companies, and the Ringling era, which ended with the real-estate crash and Depression.

Beginning in the 1940s, Sarasota began to struggle out of a decade of financial hardship. The opening of several military airstrips in Sarasota and Venice, intended to train pilots for World War II, helped fuel the recovery of the area. Few residents today can imagine a Longboat Key so empty that the beaches were used as a practice firing range. Airports were built that were transformed for commercial use after the war and the end of training. Transportation was available, and a large number of American veterans had been exposed to the beauties of the area, so some came back to settle down. With projects like building the Lido Casino in the 1940s and the growth of a tourism economy, there was a resurgence of interest in the real-estate market. A leader in this field was the Arvida Company.

Many visitors to Sarasota are surprised to find a sizeable Amish and Mennonite community in a central location near Bahia Vista Street and Phillippi Creek. This community grew throughout the 1930s. Many of its members farmed in their Ohio or Pennsylvania homes all summer and came to Sarasota to raise more crops in the winter. A permanent Amish church was founded in 1945, and a Mennonite church came in the 1950s. Other areas of Sarasota also saw considerable development through the 1940s and 1950s. As the latter decade closed, small-scale development began to be outstripped by the large-scale developments of large land companies.

Arvida started development in Sarasota with the purchase of the inactive John Ringling Properties developments around St. Armand's Key in 1959. This purchase included 1,200 acres on Longboat Key, as well as land on Bird Key, Coon Key, and Lido Key. With the success of this project, Arvida continued development in the area, building the large projects we now see over the keys. This area had been inactive for 20 years since the death of Ringling and also included the active Ringling Hotel (which has since been demolished) on the Tamiami Trail and the unfinished Ritz Carlton Hotel on the southern part of Longboat Key. At the time of the sale, putting this desirable land back into the market was seen as a big boon for the local community.

While Arvida was dominating the development of premium properties on the waterfront and the islands, several other developers turned their gaze to the extensive orange groves and agricultural land that still existed near the coast and along the Tamiami Trail. One of these developments that still exists near U.S. 41 and Clark Road is Gulf Gate. A large piece of land that held the Siesta Drive-in Movie Theater became the Gulf Gate Mall, and roads were platted throughout the area. These houses were built and sold primarily in the 1960s and are still popular homes for local citizens.

As the 1960s passed and the 1970s arrived, the developments became more affluent, the houses larger, and the amenities improved. Taylor Woodrow developed the Villages of Palm Aire, which promoted a neighborhood concept and were primarily marketed as second homes. Golf and other activities were built into the community. As tax laws changed, so did the population, and now the residents are primarily full-time residents.

The Sarasota School of Architecture influenced many buildings, including the downtown post office, the new addition to Sarasota High School, the chamber of commerce, beach pavilions, and several homes on Lido, Siesta, and throughout the community.

The 1980s and 1990s brought considerable growth to Sarasota, and permanent residents increased as a proportion of the population. The demand grew for larger, more luxurious houses, with considerable amenities. With a shortage of large tracts to build near the center of Sarasota, large developers turned to the ranches that were once located on the outskirts of the city. Ranches were given names like Lakewood Ranch and Palmer Ranch. When growth seemed to be spinning out of control, a long-term growth plan was drafted to help prevent sprawl east of Interstate 75, mandating lot-size requirements on some of these large tracts of agricultural land. The future of Sarasota is unclear, and planning authorities are writing new plans for development and infrastructure. With the competing interests of developers, residents, and special-interest groups, it will be interesting to see what the 21st century brings to Sarasota.

One

ATTRACTIONS

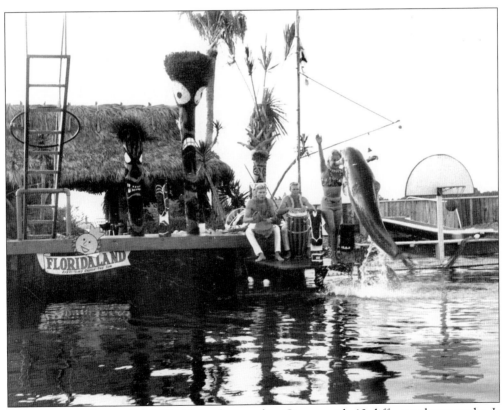

On Christmas Day in 1964, Floridaland opened in Osprey with 10 different theme parks. It claimed that it had "Everything Under the Sun." In this picture, you can see the dolphin, Moby Dick, performing in the porpoise pool at the park. The show was directed by Joyce Simpson (shown standing up with dolphin) and was accompanied by two drum players. (Courtesy of the Sarasota County History Center.)

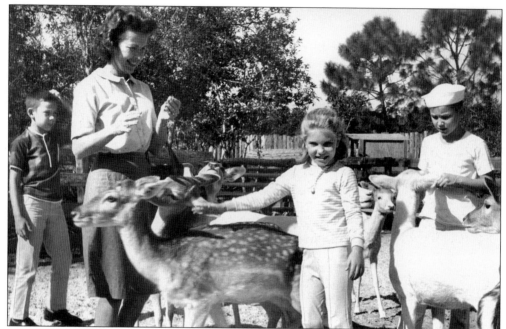

Floridaland had several theme parks that included porpoise shows, Western Ghost Town, Billy Goat Mountain, Indian Village, a deer park, Floridaland tour train, tropical gardens, a riverboat, covered wagon rides, and a can-can show. Shown here are children at the petting zoo, where they could pet, hand feed, and photograph the deer. (Courtesy of the Sarasota County History Center.)

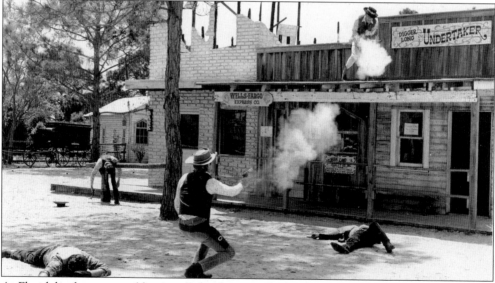

At Floridaland, guests could enjoy all the theme parks for the price of one admission. In 1967, a 100-room Holiday Inn was built on part of the 50-acre park. Pictured here is a shoot-out occurring in Western Ghost Town. Marshal Whitlock shoots at bank robbers to prevent them from making off with the money. Ironically, Floridaland closed in 1971, which is the same year that Disney World opened in Orlando. Today, the development Southbay Yacht and Racquet Club is at this location. (Courtesy of the Sarasota County History Center.)

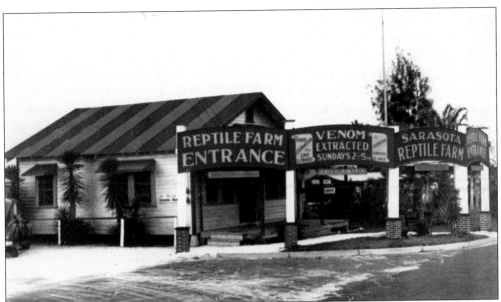

"Texas" Jim Mitchell opened his reptile farm in September 1935. Originally from the West, Mitchell was vacationing in Sarasota when he met his future wife, May, who was from Tampa. He decided to stay in Sarasota, get married, and start a business. For the next 30 years, they ran their business, which was located at Fruitville Road and Tuttle Avenue. (Courtesy of the Sarasota County History Center.)

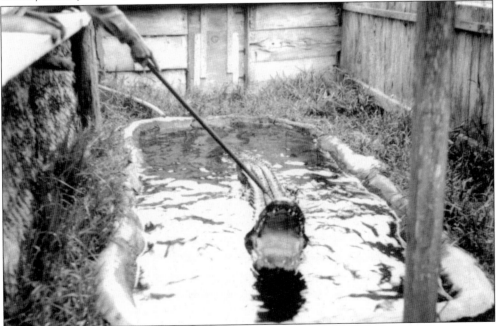

This picture of an alligator shows the modest beginning of the Texas Jim Sarasota Reptile Farm. In order to have reptiles and animals for their farm, they would go hunting at night, collecting alligators, snakes, lizards, birds, deer, and bear. One of their featured pets was an anaconda snake. For vacations, they would camp with the Seminoles in the Everglades. (Courtesy of the Sarasota County History Center.)

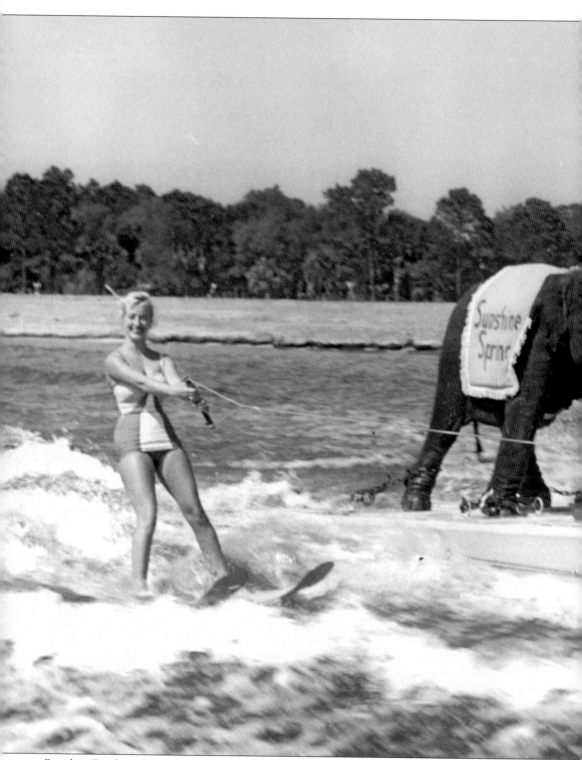

Ringling Brothers Circus loaned to Sunshine Springs and Gardens a 1,300-pound elephant that performed with the Aquabelles across the 65-acre man-made lake. The 400-acre park also had

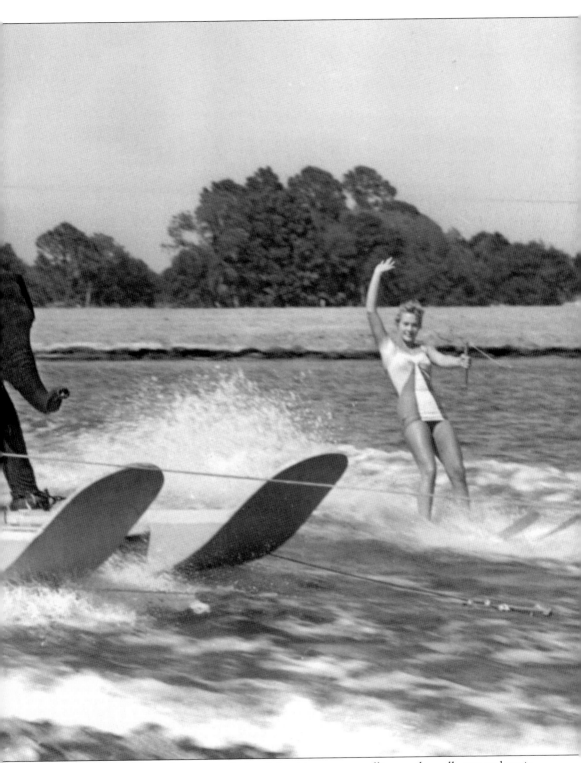

several varieties of tropical plants to admire while visitors were strolling on the walkways and rustic bridges. The park closed in the late 1950s. (Courtesy of the Sarasota County History Center.)

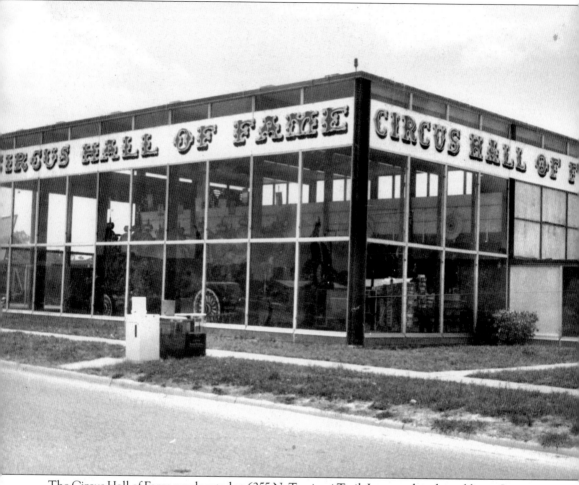

The Circus Hall of Fame was located at 6255 N. Tamiami Trail. It opened to the public on January 4, 1956. John L. Sullivan and Dr. H. Chester Hoyt decided to combine their extensive circus collections and open the attraction. One of the attractions was the "Two Hemisphere Chariot," which was built for P. T. Barnum in 1896 and required 40 horses to pull the 10-ton wagon. Later the wagon was used in the Ringling Brothers and Barnum and Bailey Circus. Col. B. J. Palmer of Sarasota had the wagon restored, and he donated this valuable piece of history to the Circus Hall of Fame. (Courtesy of the Sarasota County History Center.)

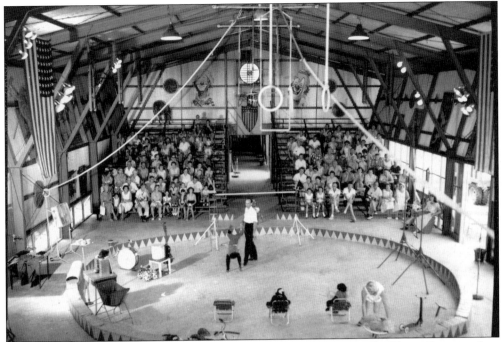

This picture, taken in the early 1960s, is of a live show at the Circus Hall of Fame. For more than 20 years, this attraction offered daily professional circus acts, puppet shows, tours, and a sideshow museum. (Courtesy of the Sarasota County History Center.)

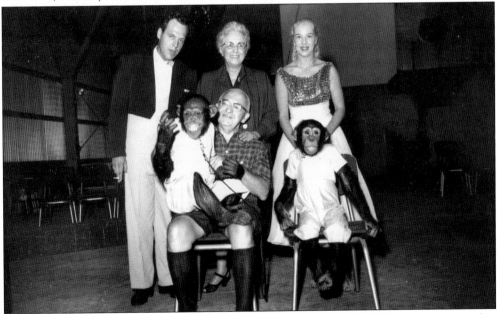

Some performers from the Circus Hall of Fame are shown here in 1958. The attraction tried to honor circus stars, maintain a circus history library, collect and display mementos of the stars, and inform people about the educational and recreational value of the circus. A committee of 12 circus historians was assigned to choose circus personalities to be included in the Circus Hall of Fame. The museum closed in 1980. (Courtesy of the Sarasota County History Center.)

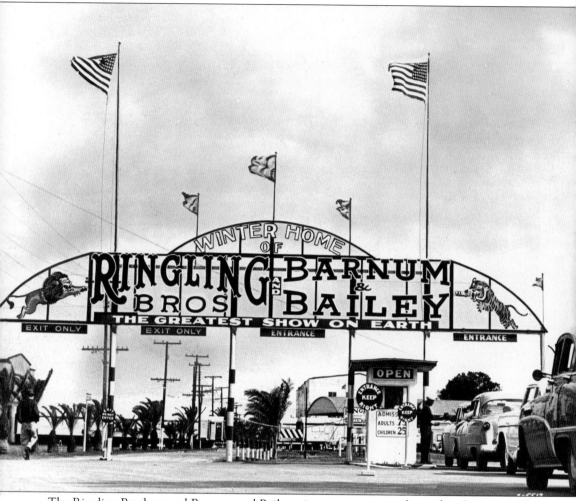

The Ringling Brothers and Barnum and Bailey winter quarters were located in Sarasota at the old fairgrounds and airfield, located north of Fruitville and east of Beneva, which served as the winter quarters for over 30 years. The circus first came to Sarasota in 1927. Promoters hoped that the circus would bring residents to Sarasota. For the first 10 years, the county commission paid John Ringling a "publicity fund," which equaled the amount of the state and county taxes. The circus moved to Venice in 1962 and wintered there until 1992. (Courtesy of the Sarasota County History Center.)

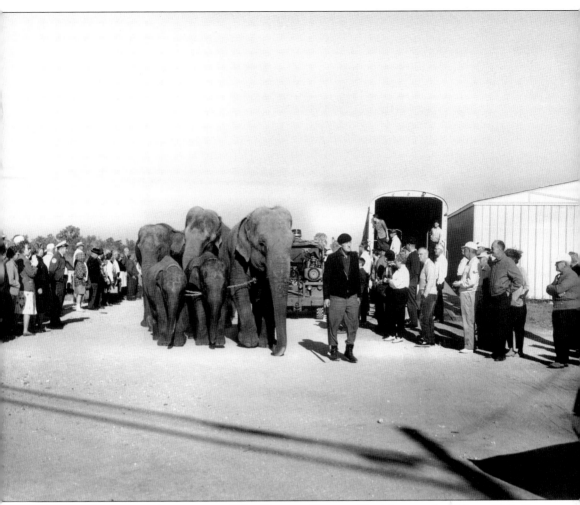

Arriving for its annual winter tour, "The Greatest Show on Earth" stopped traffic on U.S. 41. Elephants, horses, and ponies marched through the streets. Residents looked forward to the arrival of the circus in anticipation of seeing live animals parading. (Courtesy of the Sarasota County History Center.)

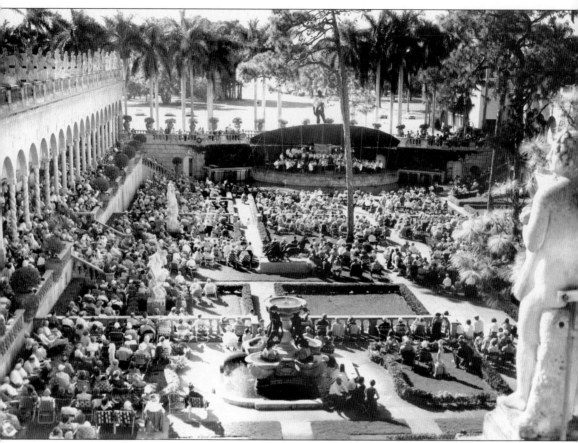

This photograph shows the Sarasota Concert Band performing in front of 6,500 people in the courtyard of the John and Mable Ringling Museum of Art. In 1962, the band was invited to play at the museum due to scheduling conflicts at the auditorium and casino. They played at the museum from 1962 through 1966. In 1973, the band wanted to find a permanent place to perform and agreed on the Van Wezel Performing Arts Hall. (Courtesy of the Sarasota County History Center.)

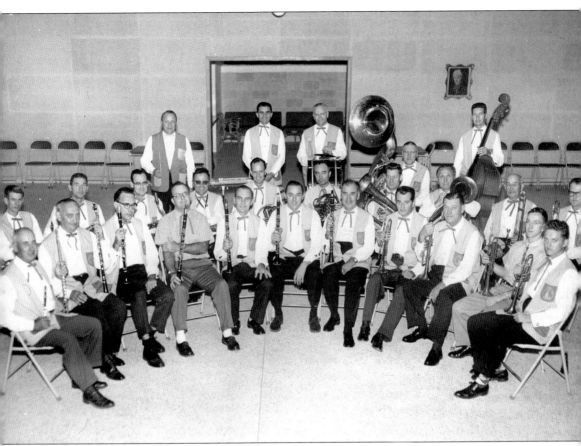

The Sarasota Concert Band performed its first free concert in 1955 at the Lido Casino with about 20 musicians. Throughout the 1950s, it played at several locations, including Southgate Shopping Center, Bay Front Park, Payne Park, the municipal auditorium, and even the Palmer Bank parking lot. By the 1960s, the Sarasota Concert Band had expanded to 35 professional members and 35 students from local high schools and colleges. The students needed to be recommended by a teacher to play, which gave them exposure and practice by performing in front of live audiences. In the front row, second from right, is Eddie Egars. On bass in the back, to the right, is Wilmer C. Banks. (Courtesy of the Sarasota County History Center.)

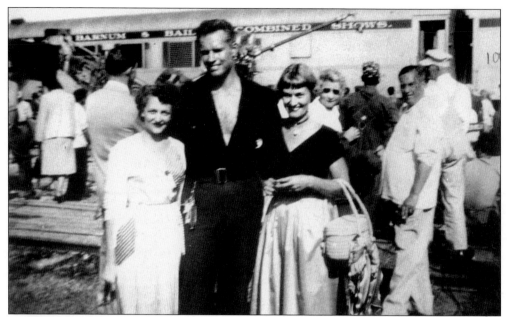

For three months in 1951, Sarasota was full of excitement due to the filming of the *Greatest Show on Earth*. Cecil B. DeMille hired over 1,000 Sarasotans as extras. This picture shows Charlton Heston with Orine Stewart to the right on the movie set. (Courtesy of the Sarasota County History Center.)

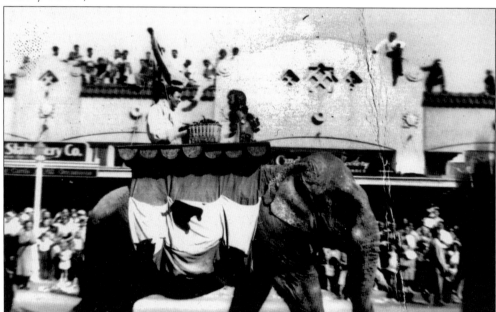

Actors Cornell Wilde and Gloria Grahame are riding down Main Street in Sarasota during the filming of *The Greatest Show on Earth*. Hundreds of people turned out for the parade, which traveled through First and Main Streets and Central and Orange Avenues, covering the route two times. The film premiered a year later at the Florida Theater (today known as the Sarasota Opera House). Many residents enjoyed seeing their families, friends, and neighbors as extras in the film. (Courtesy of the Sarasota County History Center.)

The Trail Drive-In Theatre

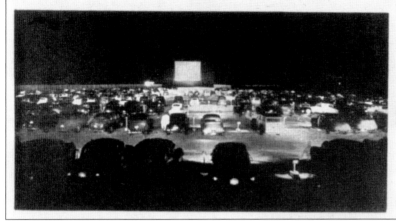

Visit the South's Finest — Largest Drive-in Theatre.

North Tamiami Trail Opposite the Sarasota-Bradenton Airsite. Phone 55-714.

This picture shows an ad for the Trail Drive-In Theatre. It was advertised as the "South's Finest Largest Drive-In Theatre." Residents enjoyed bringing the whole family to this affordable event, which cost $3 a carload. (Courtesy of the Sarasota County History Center.)

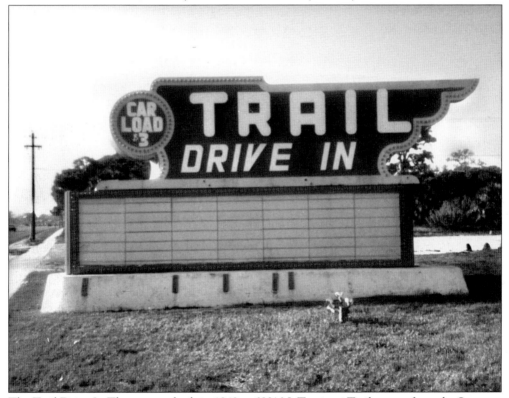

The Trail Drive-In Theatre was built in 1949 at 6831 N. Tamiami Trail, across from the Sarasota Bradenton Airport. The theater had space for 780 cars and offered movies, food (including shrimp or chicken dinners), and playgrounds for the children. (Courtesy of the Sarasota County History Center.)

This is a picture of Mrs. Bill McAdams, a tourist from Baltimore, Maryland who visited the Lido Casino in 1946. The casino was enjoyed by visitors and residents, and during World War II military personnel came from local bases. Sadly, the Lido Casino was demolished in 1969. The Sarasota County Historical Society has dedicated a marker for the casino and its architect, Ralph Twitchell. (Courtesy of the Sarasota County History Center.)

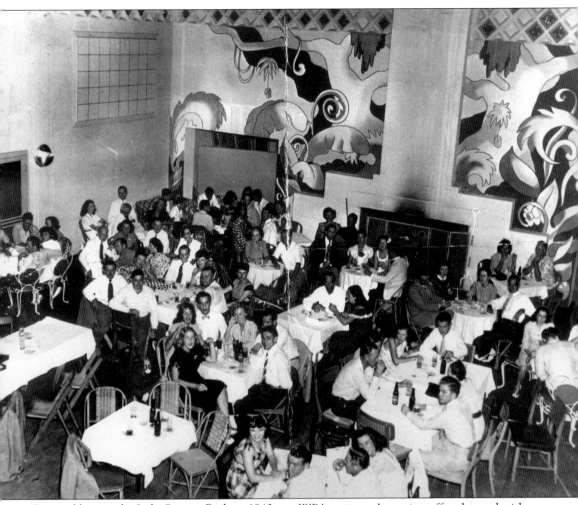

Pictured here is the Lido Casino. Built in 1940 as a WPA project, the casino offered a pool with a high dive, cabanas, shops, restaurants, and a ballroom. Architect Ralph Twitchell designed the art-deco casino using a modern design and materials. Glass blocks, white walls, and large sculptures offered Sarasotans fun and stylish accommodations. Here is a picture taken in 1948 of the interior of the Lido Casino during the Tarpon Ball. (Courtesy of the Sarasota County History Center.)

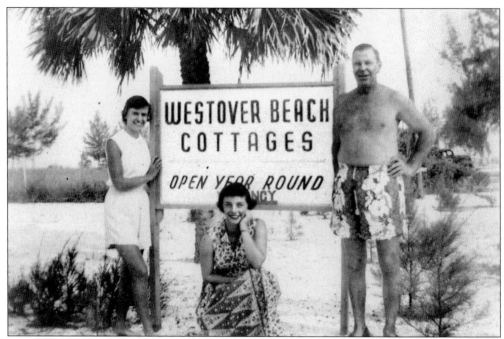

The Westover Beach Cottages were located at 5500 Gulf of Mexico Drive. Like Siesta Key after World War II, Longboat Key started developing small hotels and beach cottages. Mr. and Mrs. Howard Knapp, the proprietors of the cottages, advertised "modern living accommodating six persons to a cottage, spacious five-room cypress cottages, furnished with all modern conveniences." Pictured, from left to right, are unidentified, Pat Knapp Hatzler, and unidentified. (Courtesy of the Sarasota County History Center.)

The Westover Beach Cottages offered basic beach living for a reasonable cost. The price for a week was $90 off-season and $225 during high season. (Courtesy of the Sarasota County History Center.)

The Turtle Beach Cabanas offered Sarasota residents fun in the sun. Along with the cabanas, a common area called the "Centrale" was also constructed for the board of directors and for large parties to meet. In 1952, some of the original members sold their shares and started the Siesta Key Club (known as the Sanderling Club today). (Courtesy of the Sarasota County History Center.)

After World War II, Siesta Key became a popular place among wealthy residents and visitors. Developer Eldridge S. Boyd, a member and driving force of the Siesta Key Association, decided to build cabanas for the enjoyment and promotion of Siesta Key. At the time, there was only one public beach access south of Siesta Key Village. Boyd's vision was to build a beach community of "like-minded people" and to provide beach access for his land-locked property. The plan was to build 32 10-foot-by-10-foot cabanas that would have covered porches that faced the gulf. (Courtesy of the Sarasota County History Center.)

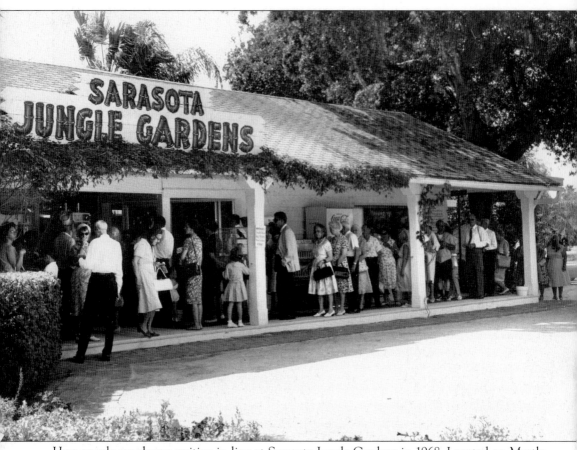

Here people are shown waiting in line at Sarasota Jungle Gardens in 1968. Located on Myrtle Street in the Indian Beach area, the park was developed by David B. Lindsay, H. R. Taylor, and Pearson Conrad. (Courtesy of the Sarasota County History Center.)

Sarasota Jungle Gardens opened its doors on New Year's Eve in 1939. Thousands of varieties of plants from around the world were planted when the garden opened. Today you can see daily reptile and bird shows. In this picture, two boys enjoy petting an alligator whose mouth has been banded. (Courtesy of the Douglas C. Elder.)

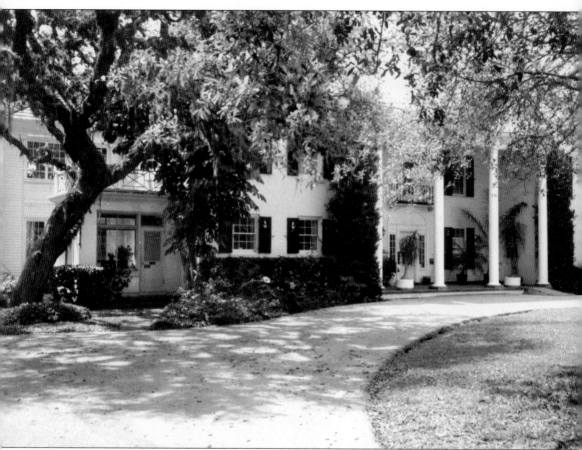

The Christy Payne mansion, located today on the Marie Selby Botanical Gardens property, was built in 1935 for Christy Payne. Payne was a wealthy businessman who retired from Standard Oil. He bought the overgrown property located on the corner of Mound Street and Tamiami Trail to build a mansion for his retirement. Payne studied many photographs of other mansions, including the Franklin Jones House located in Sewicky, Pennsylvania, which was allegedly the model for his mansion. Architect A. C. Price and builder Paul Bergman designed and constructed the hurricane-proof house. After Payne's death in 1962, Dr. and Mrs. James Paulk bought the house and then sold it in 1973 with the stipulation that it would become part of the Gardens. (Courtesy of Douglas C. Elder.)

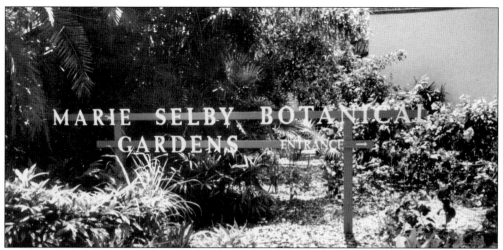

The Marie Selby Botanical Gardens are located at 922 S. Palm Avenue. This picture of the sign was taken in the late 1980s. Marie and William Selby bought five acres of land on Sarasota Bay and built a modest Mediterranean-style house in 1921. The house was supposed to be a gatehouse for a future "grand house," but Marie Selby decided she liked the smaller accommodations. The Selbys moved to Sarasota for the fishing and boating. Marie Selby was fond of gardening and was a charter member of the Founders Circle, the first garden club in Sarasota, established in 1927. Before her death, Marie Selby set up a trust that would maintain a botanical garden on her beautiful property. The gardens opened to the public in July 1975. (Courtesy of the Sarasota County History Center.)

Today the Marie Selby Botanical Gardens are internationally recognized for research, educational classes, the orchid collection, the cloning lab, and unusual displays. In the garden is a 14,000-square-foot greenhouse, which is used for research and the display of rare plants. In the greenhouse are colorful orchids, bromeliads, ferns, and other rare plants. There are several mature trees on the property including the red silk tree, which looks like something out of a Dr. Seuss book while in bloom, and a bo tree, which was saved from demise by a crane after a hurricane knocked it over. The garden specializes in epiphytes, which are also known as air plants. If you take the time to look up into the trees, you can see various bromeliads, including Spanish moss and several orchid species. Pictured here is a eucalyptus torelliana tree with a red silk tree blooming in the background. (Courtesy of Ruth E. Wishengrad.)

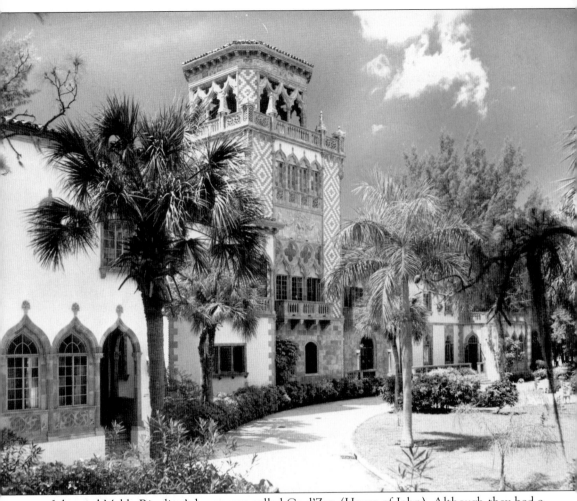

John and Mable Ringling's house was called Ca d'Zan (House of John). Although they had a residence in New Jersey, the Ringlings enjoyed spending a few months a year at Ca d'Zan after the circus season ended. Built between 1924 and 1926, the home was designed by the well-known and experienced architect from New York, Dwight Baum. The house is in a Gothic-Venetian style, which resembles the Doge's Palace in Venice. After years of decay due to humidity and neglect, Ca d'Zan has recently gone through a multi-million dollar renovation. Private grants and money from the legislature have restored this beautiful and unique sea-side mansion to its original grandeur. (Courtesy of the Sarasota County History Center.)

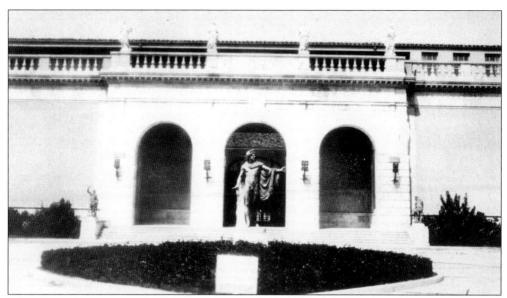

The John and Mable Ringling Museum is located at 5401 Bayshore Road. The Ringlings collected art from all over Europe for their collection. In 1932, the museum opened to the public, and in 1946, the state of Florida officially accepted the museum. The extensive collection includes paintings by El Greco and Rembrandt, as well as several works by Rubens. The Ringlings acquired several valuable masterpieces in just five years while they traveled extensively to Europe in search of circus acts. Ringling was fortunate to be purchasing paintings during a time when aristocrats were obligated to sell. He purchased 33 paintings between 1927 and 1928 from the Holford collection at Christie's in London, including a portrait of Philip IV. (Courtesy of the Sarasota County History Center.)

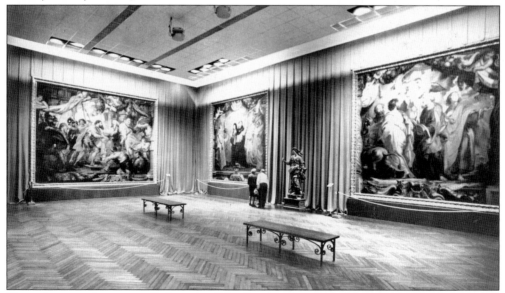

Shown here are the gigantic Rubens that John Ringling bought for his museum. The nine Rubens paintings were estimated to be worth $80 million when they were recently insured. Four of them are called tapestry cartoons, which are up to 14 by 19 feet in size. (Courtesy of the Sarasota County History Center.)

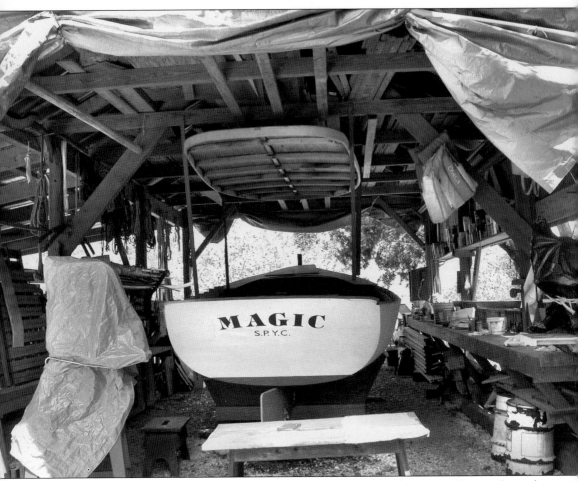

In 1980, the Palmer family generously deeded the 30-acre property known as Historic Spanish Point to the Gulf Coast Heritage Association. The non-profit association agreed to use this historic site as a museum on the prehistoric, homestead and Palmer areas. Shown here is a replica of the Webb's boat *Magic* being rebuilt by volunteers using just a photograph as a blueprint. (Courtesy of Amy Elder.)

In 1996, Historic Spanish Point was able to purchase and convert the old Osprey School for offices and a visitor center. The school, which is located on U.S. 41 in Osprey, was built in 1927 for the community of Osprey. Since its renovation, the former school provides space for a gift shop, offices, displays, and exhibits, and it offers a meeting center that is centrally located in the county. (Courtesy of Historic Spanish Point.)

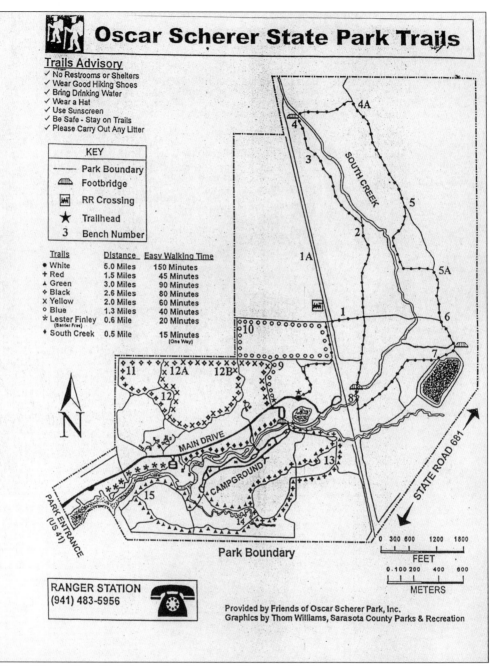

Oscar Scherer State Park Trails

Trails Advisory
✓ No Restrooms or Shelters
✓ Wear Good Hiking Shoes
✓ Bring Drinking Water
✓ Wear a Hat
✓ Use Sunscreen
✓ Be Safe - Stay on Trails
✓ Please Carry Out Any Litter

KEY
-------	Park Boundary
🚉	Footbridge
🚉	RR Crossing
★	Trailhead
3	Bench Number

Trails	Distance	Easy Walking Time
● White	5.0 Miles	150 Minutes
+ Red	1.5 Miles	45 Minutes
▲ Green	3.0 Miles	90 Minutes
◇ Black	2.6 Miles	80 Minutes
x Yellow	2.0 Miles	60 Minutes
○ Blue	1.3 Miles	40 Minutes
✱ Lester Finley (Barrier Free)	0.6 Mile	20 Minutes
✦ South Creek	0.5 Mile	15 Minutes (One Way)

RANGER STATION
(941) 483-5956

Provided by Friends of Oscar Scherer Park, Inc.
Graphics by Thom Williams, Sarasota County Parks & Recreation

Oscar Scherer State Park, located in Osprey on Tamiami Trail, provides enjoyment for both folk and fowl. Originally the park was a chicken farm owned by a retired surgeon and his wife, Walter and Elsa Burrows. The Burrows moved here in the 1930s and stayed for two decades on their property, which they called the South Creek Farm. Mrs. Burrows willed the land to the state in 1951 and named it after her father, Oscar Scherer. She stipulated that the land must be used for a public park and restricted hunting of wild animals. The park opened in the summer of 1959. (Courtesy of the Sarasota County History Center.)

Oscar Scherer State Park provides a habitat for a wide variety of animals. Campers see numerous alligators swimming in the fresh water. According to the Burrows' daughter, this was also the case when her parents lived on the farm. She said occasionally their chickens would be eaten by one of the many alligators. Today alligators swim in South Creek and sometimes come into the surrounding waterfront neighborhoods including Sorrento Shores, located downstream from the park. (Courtesy of the Sarasota County History Center.)

Children explore nature at Myakka State Park. One boy opts to view the park from a live oak tree branch. Myakka State Park contains 28,875 acres. In the 1930s, a group of local citizens formed the Sarasota Game Commission to establish game protection. The same year, the Internal Improvement Fund (IIF) purchased 17,000 acres for 37 1/2¢ an acre from the A. C. Honore Estate. Potter Jr. and Honore Palmer also donated 1,900 acres in honor of their mother, Mrs. Potter Palmer. The Civilian Conservation Corps (CCC) cleared trees, dug drainage ditches, and built wooden cabins and picnic shelters that can still be used today. The park was dedicated in 1941 and opened to the public on June 1, 1942. Today Myakka State Park is one of Florida's oldest and largest wilderness preserves. (Courtesy of the Sarasota County History Center.)

This picture shows a couple enjoying the shade under large live oak trees adorned by Spanish moss at Myakka State Park campground. There are several fun things to do at Myakka, including bird watching, hiking, camping, walking a tree-top-canopy walk, picnicking, horse riding, and boat riding on the river among the numerous alligators. A flock of rosette spoonbills was once spotted near the dam. (Courtesy of the Sarasota County History Center.)

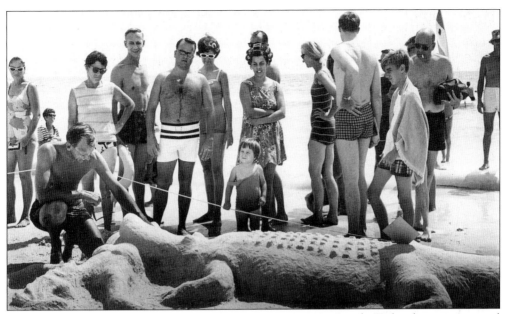

This alligator was part of a sand sculpture contest on Siesta Key Beach. Today there is an annual contest in early May sponsored by the Sarasota County Parks and Recreation Department. The contest is free, and there are categories for children and adults. The sand sculptures are judged, and cash prizes are given to the winners. In 2005, participants celebrated 35 years of sand-building fun. (Courtesy of the Sarasota County History Center.)

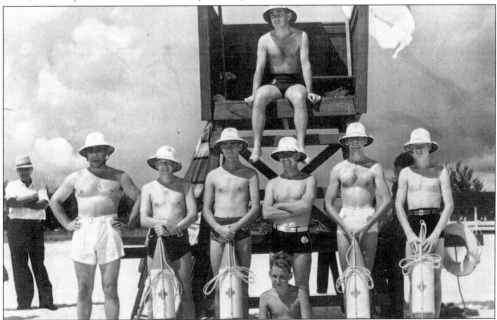

Sarasota County lifeguards pose here for a picture c. 1950. Today Sarasota has six picturesque beaches that include world-renowned Siesta Key Beach, Lido Beach, Manasota Beach, Nokomis Beach, North Jetty Beach, and Venice Beach. Lifeguards work year round at Lido, Siesta, Nokomis, and Venice Beaches. Behind the lifeguards is the old wooden structure that used to be on Lido Beach. (Courtesy of the Sarasota County History Center.)

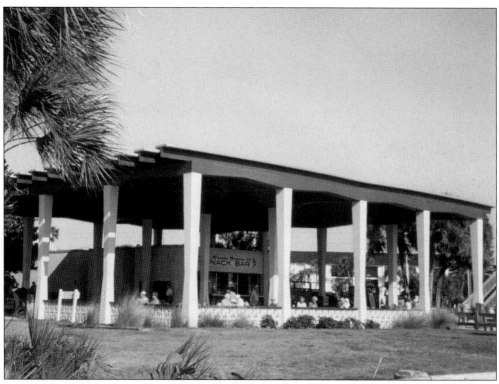

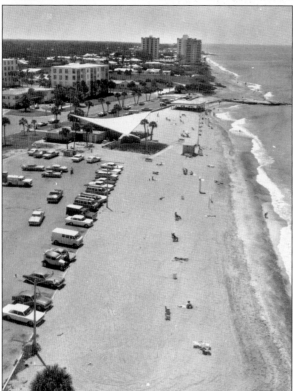

The Siesta Key Beach pavilion was designed by Edward "Tim" Siebert. Like Venice and Nokomis pavilions, this pavilion combines elements of the environment both outside and inside the building. (Courtesy of the Sarasota County History Center.)

The Venice Bathhouse is located at the west end of Venice Avenue. The architect, Cyril T. Tucker, and builder, William Lyndh, created this modern public facility. They tried to reflect the environment with the hyperbolic parabolic shape. The pavilion cost $54,000 to build in 1964. (Courtesy of the Sarasota County History Center.)

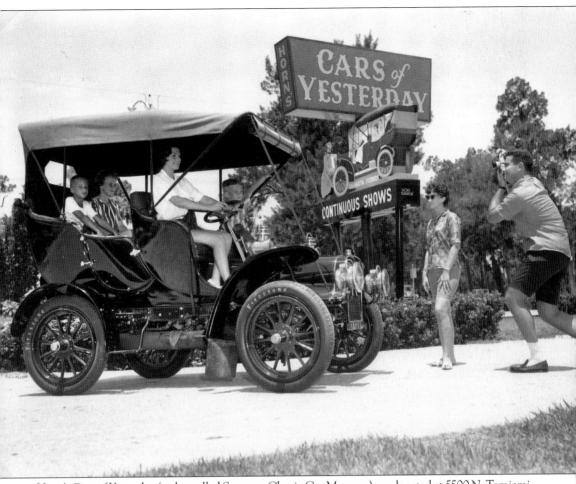

Horn's Cars of Yesterday (today called Sarasota Classic Car Museum) was located at 5500 N. Tamiami Trail. It opened in 1953. Today the museum is non-profit and one of the longest continuously running car museums in the United States. The museum features over 100 automobiles from the past including muscle, classic, vintage, and exotic models. Beatles fans can see Paul McCartney's Mini Cooper and John Lennon's Mercedes roadster. (Courtesy of the Sarasota County History Center.)

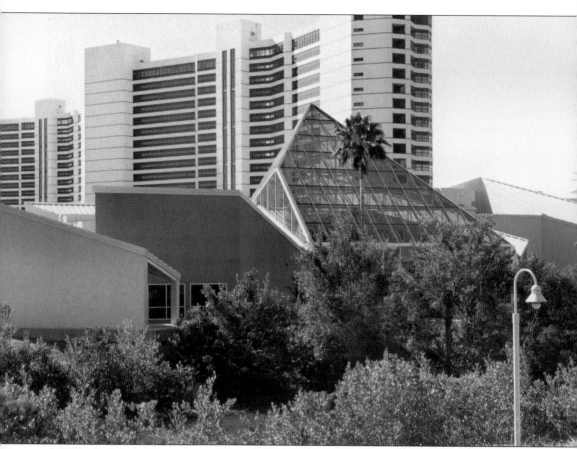

G.WIZ, the hands-on science museum, is located at 1001 Boulevard of the Arts. The building originally housed the Selby Public Library, until it was remodeled to accommodate this wonderful learning center. G.WIZ (Gulf Coast Wonder and Imagination Zone) began in 1990 as the Gulf Coast World of Science. In 1993, the Sarasota City Commission voted to let G.WIZ have a permanent home in the old Selby library. A 20-year lease was provided, and in May 1998, the hands-on science museum opened. (Courtesy of Amy Elder.)

G.WIZ, the hands-on science museum, provides children and adults with an educational and fun interactive science center. The ExploraZone has exhibits from the Exploritium Museum in San Francisco; Sutton Garden includes a butterfly garden and ecosystem with real snakes, bees, and turtles; the Kids Lab is for young explorers under six; visitors can design a robot or create an animated film in the Technology Gallery; the Wave Zone experiments with light and sound waves and includes a sound studio; the Aerobic Challenge tests visitors' strength and flexibility and promotes fitness; and finally there is a science-themed outdoor playground for ages 6–12. Here a student enjoys soap-film painting. (Courtesy of Richard Thayer.)

Pictured here are two children having fun watching a ball blown up to the ceiling at the Bernoulli Blower, part of G.WIZ. The air floating around and above the ball is moving faster than the air below, so there are pressure differences between the top and bottom of the ball. The higher pressure underneath the ball pushes up enough to balance the force of gravity. (Courtesy of Richard Thayer.)

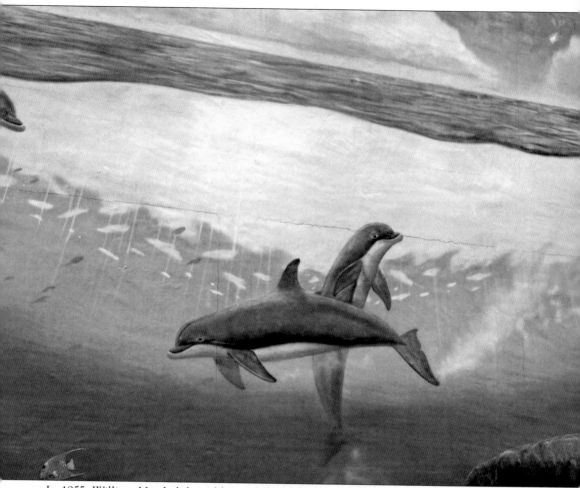

In 1955, William Vanderbilt and his wife hired Eugenie Clark to be the director of the Cape Haze Marine Laboratory, located in Placida, Florida. When she resigned for a couple of years, Perry Gilbert, a scientist and professor from Cornell, was asked to take over. He agreed to be an interim director for one year and stayed for over 20. During this time, William Mote helped with growth and financial difficulties, and the name was changed to Mote Marine Laboratory. Mote and Gilbert made a good team and were determined to help the lab continue to grow. In the late 1970s, the lab was running out of space. The two men visited several marine labs and negotiated for a much larger facility to be built on City Island. Gilbert retired at the completion of the new facility in 1978. Pictured here is a whaling wall painted by Wyland. (Courtesy of Amy Elder.)

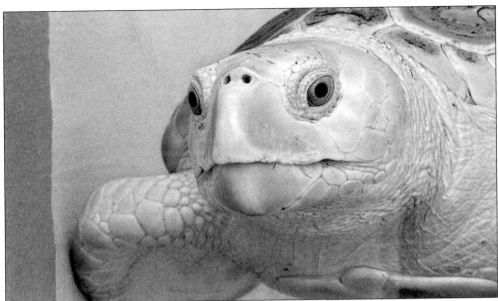

Here is a picture of a temporary resident of Mote Marine. Mote's Sea Turtle Rehabilitation Hospital treats injured sea turtles. Since 1990, Mote has been authorized by the Florida Fish and Wildlife Conservation Commission for their rehabilitation. Sarasota County is fortunate to have the largest loggerhead turtle nests on the west coast of Florida. Other types of turtles include green, hawksbill, leatherback, and Kemp's ridley turtles. During nesting season, volunteers comb the beach, put stakes around nests, make sure hatchlings have left the nest safely, and remind people to turn off their lights at night. (Courtesy of Mote Marine Laboratory.)

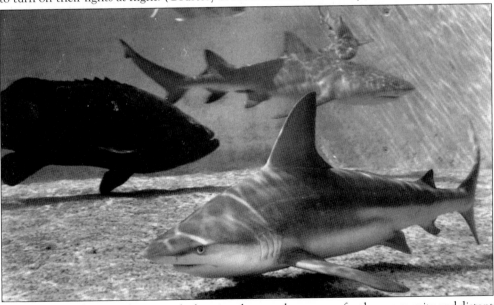

Mote Marine Laboratory has several educational outreach programs for the community and distant learners. Two of the most popular programs are the Jason Project and SeaTrek. Both programs are available for free via videoconferencing to students all over the world. Students can interact with scientists to learn more about science and marine biology. Shown here is a sand shark that lives in a large tank at Mote Marine. (Courtesy of Mote Marine Laboratory.)

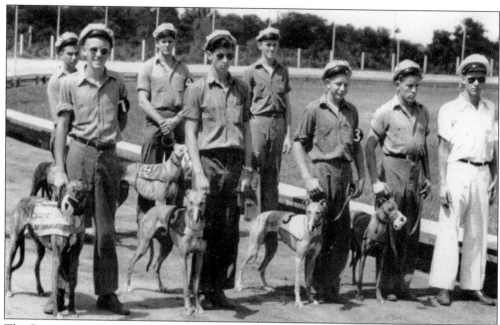

The Sarasota Kennel Club (SKC) provided scholarships for Manatee Community College and the University of South Florida. The SKC has been owned by the Collins family for over 60 years. The late Jerry Collins bought the business in 1945. He ran the club for years, saying he enjoyed "walking the beat." His son, Jack, and two grandsons, Jack Jr. and Chris, are running the SKC and the club in St. Petersburg. Pictured, from left to right, are the following: (first row) unidentified, Bud Zuckerman, and unidentified; (second row) Edie Wiesner, unidentified, and Jim Bowlander. (Courtesy of the Sarasota County History Center.)

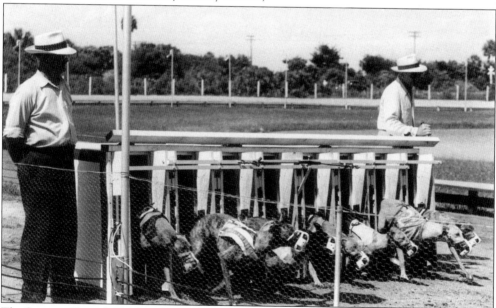

The Sarasota Kennel Club has changed the way you can bet. Thanks to inter-track wagering with live satellite television coverage, customers can watch dogs race live and also see and bet on dog and horse races in other cities and states. (Courtesy of the Sarasota County History Center.)

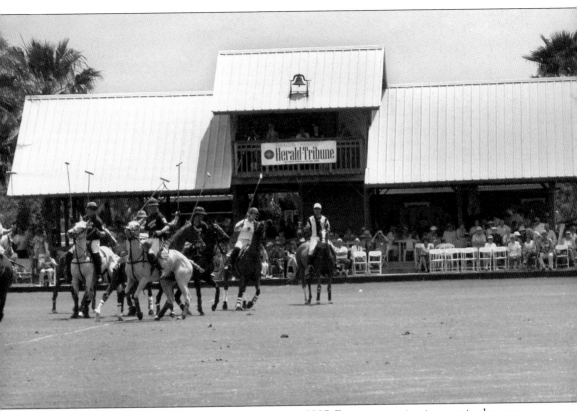

The Sarasota Polo Club celebrated its 14th season in 2005. Due to a growing interest in the game, the polo club just installed new bleachers that hold up to 750 people and offered season passes for tailgating. The Sarasota Polo Club has teamed up with ESPN and MVP sports and will be hosting the first leg of the Triple Crown of Polo. The field becomes colorful with bright umbrellas and tablecloths during matches. The action and speed of the game is exhilarating. (Courtesy of Amy Elder.)

McCurdy's Comedy Club and Humor Institute has been in Sarasota for 18 years and is owned by Pam and Les McCurdy. The club has have been located throughout Sarasota, starting at The Big Kitchen restaurant on Clark Road, moving to the Holiday Inn Marina (for 10 years), and finally moving to a great location in 2001, located on Tamiami Trail near Jungle Gardens and Myrtle Street. McCurdy's is an entertaining place to bring family, friends, and guests. Beware: if you sit up-front, you might be jested. (Courtesy of Amy Elder.)

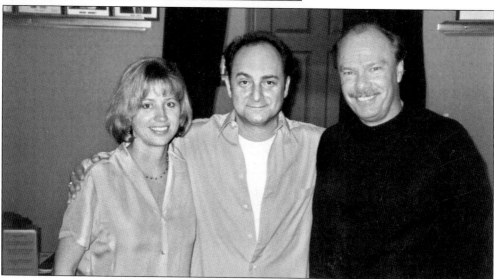

Les McCurdy started a comedy club called Comedy Catch in Chattanooga, Tennessee, before moving to Sarasota. He met his wife, Pam, in 1982 while she was attending the Asolo for her master of fine arts degree. Both Pam and Les are committed to the community. They support Girls Inc., SPARK, and Children First. They require their employees to be involved with a local charity and host a charity golf event, which contributed to Camp Florida Fish Tales for handicapped children. Their humor institute is branching out by offering workshops to corporations including a team-building workshop for Sarasota County principals. Pictured, from left to right, are Pam McCurdy, guest comedian Kevin Pollack, and Les McCurdy. (Courtesy of Chris Johnson.)

Two

CULTURE

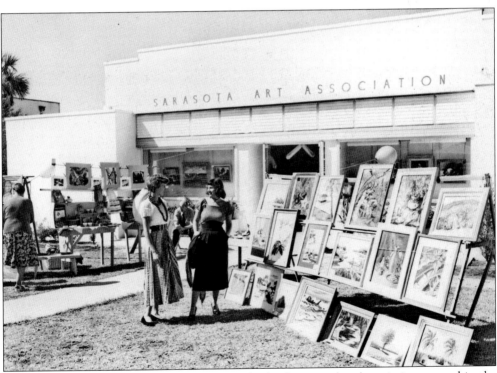

The Art Center Sarasota, which was previously the Sarasota Art Association, started in the 1920s. Marcia Rader, who was the art supervisor for Sarasota County schools, sought support for the art center. It did not have a permanent home until 1948, when the City of Sarasota donated a parcel of land. The members raised $12,000 for the building located in the Civic Center next to the Chidsey Library. This photograph, taken in 1950, shows the Art Center Sarasota celebrating Pageant Week with an outdoor art show. (Courtesy of the Sarasota County History Center.)

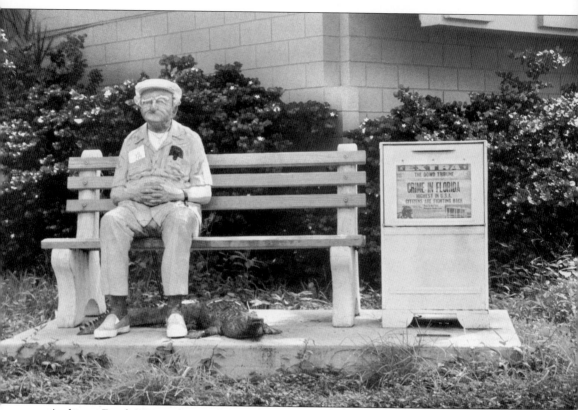

Architect Frank Martin designed and generously donated the plans for the original Art Center Sarasota in 1950. In the following season, he also made additional plans to incorporate patio galleries in back of the building. The building was enlarged again in the 1960s to expand the gallery. The Sculpture Garden, located on the grounds of the Sarasota Art Association, was installed in 1995. This photograph shows local artist Jack Dowd's sculpture, which includes a tourist, an alligator, and a newspaper rack. (Courtesy of the Sarasota County History Center.)

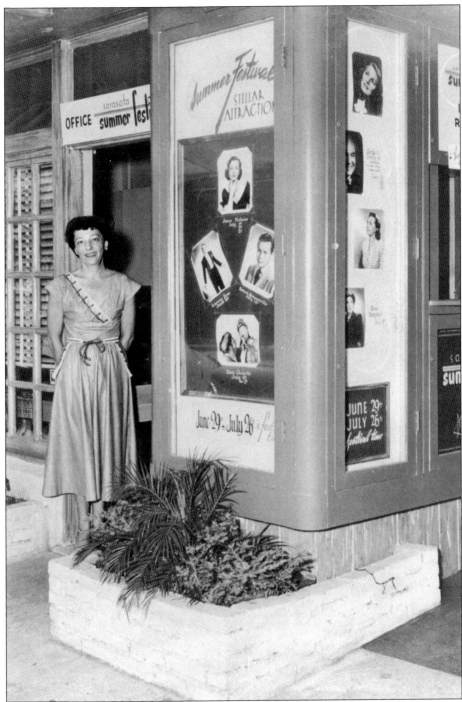

Sarasota has a long tradition of celebrating the arts. In 1953, the Sarasota Foundation, Inc., planned a summer arts festival. Foundation president Kent S. McKinley worked to organize the summer arts program in the hopes of attracting tourists and artists from around the United States. With the help of the foundation's director, G. O. Shepard, an arts, crafts, and photography show was set up along with other cultural events. (Courtesy of the Sarasota County History Center.)

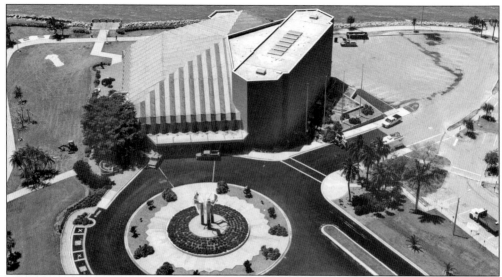

The Van Wezel Performing Arts Hall was built in 1969 thanks to the generosity of local philanthropists Eugenia and Lewis Van Wezel and a bond from the City of Sarasota. The architect, William Wessley Peters, wanted the architecture to be a seashell form. The exterior color is purple, which was chosen by Peters's wife. Peters is an architect working for Taliesin Associate Architects of the Frank Lloyd Wright Foundation. He worked on nationally renowned projects such as Fallingwater and the Guggenheim Museum. The Van Wezel Arts Hall is located at 777 N. Tamiami Trail. This aerial photograph shows the building soon after it was built during 1968 and 1969. (Courtesy of the Sarasota County History Center.)

The Van Wezel Performing Arts Hall offers several types of entertainment as well as educational programs including dance, music, and theater. Thousands of students and hundreds of teachers learn about the arts each year through the Van Wezel's partnership with the Sarasota County School Board and the John F. Kennedy Center Partners in Education Program. The City of Sarasota operates the Van Wezel through a seven-member committee and director John D. Wilkes. During construction, a tent was used for performances. This picture was taken in 1999 during renovations to the Van Wezel. (Courtesy of the Sarasota County History Center.)

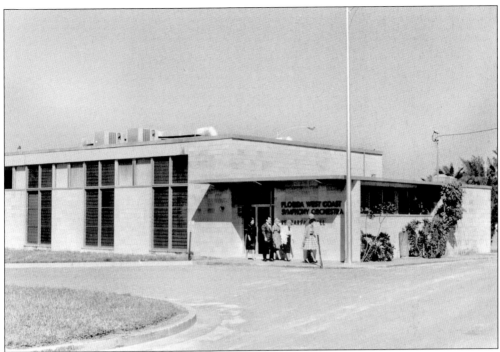

The Florida West Coast Symphony Orchestra is located at 709 Tamiami Trail in Sarasota. This was one of the first rehearsal halls in the United States in which local orchestras could perform. Thanks to the foresight of a local music teacher named Mrs. Ruth W. Butler, plans were made in 1949 to organize a local symphony. The Florida West Coast Symphony Orchestra was developed with the help of three others. In 1954, permission was granted to build the symphony hall on the grounds of the Civic Center. (Courtesy of the Sarasota County History Center.)

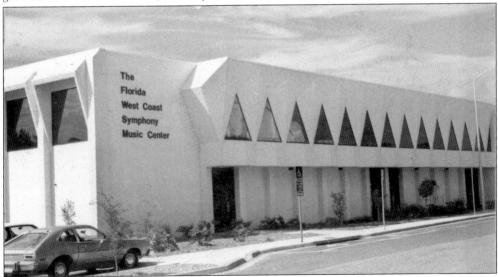

The Florida West Coast Symphony Music Center was designed by symphony clarinet player Erwin Gremil II. The building was expanded in 1965 and 1981. The hall was renamed for Beatrice Friedman who was devoted to, and participated in, several aspects of the symphony. (Courtesy of the Sarasota County History Center.)

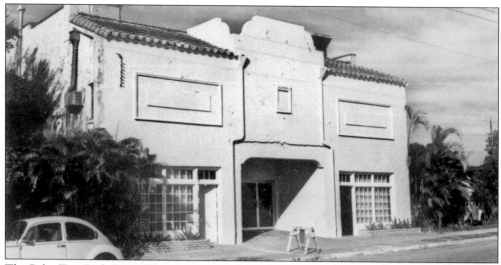

The Palm Tree Park Seven Theater was located at 1241 First Street. The building has been used for entertainment since the 1920s. The building was first used as the Park-Seventh movie house. Early Sarasotans could enjoy movies there until it closed in the 1930s, after the land boom went bust. The building was not used again until after World War II, when it opened in the early 1950s as the Palm Tree Playhouse. Stuart Lancaster, son of Hester Ringling Lancaster and grandson of Charles and Edith Ringling, brought professional theater to Sarasota. Lancaster hired actors, both locally and from New York, to perform a nine-play season. The playhouse closed in 1962, and the building was not used again until the mid-1970s, when the Theater Asolo moved in. Now the building is being occupied by Florida Studio Theater Extension. (Courtesy of the Sarasota County History Center.)

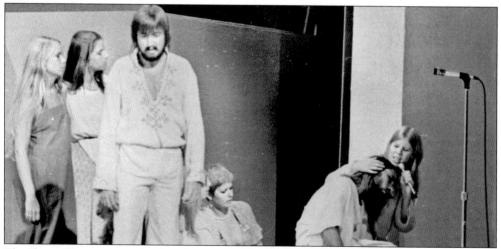

The Players Theater, located at Broadway and Fifteenth Street, started in 1930 on Siesta Key thanks to a group of Sarasota residents. Two residents who helped make this possible were Katherine Gavin and Fanneal Harrison, founders of the Out-Of-Door Academy. Through the years, the theater has grown and seen many directors, including some familiar Sarasota names such as Ringling, Sanford, Brown, Halton, Twitchell, Prew, Burns, Jones, and Higel. A new playhouse was built in the early 1970s next door to the original. This is a picture of the performance *Jesus Christ Super Star* taken in the late 1960s in the old wooden Players Theater. (Courtesy of the Sarasota County History Center.)

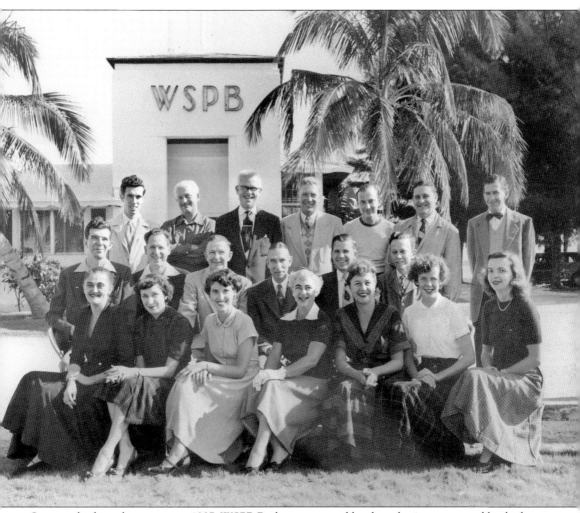

Sarasota had a radio station in 1927. WSPB Radio was started by three businessmen and backed by the Chamber of Commerce. The radio station was moved to City Island in 1939. Over the years, the station has been bought and sold several times, including to the CBS Radio Network. This photograph was taken in front of the station. Included in the picture, from left to right, are the following: (first row) JoAnne King, Marie Richardson, Jay Belle, Petey Swalm, Dottie Mead, Eleanor Brown, and Ruth Hearn; (second row) Al Marlow, J. "Mac" Miller, unidentified, Mr. Jones, Dean Fleischman, and David Hale; (third row) Don Priest, Bandal Linn, Hack Swain, Herb Splander, Jimmy Grant, Paul Roberts, and Woody Thayer. (Courtesy of the Sarasota County History Center.)

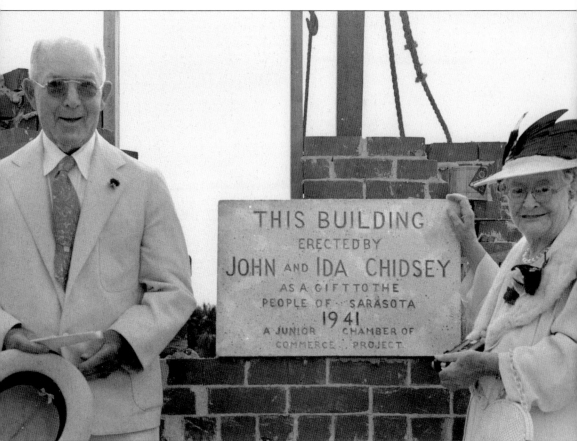

THIS BUILDING
ERECTED BY
JOHN AND IDA CHIDSEY
AS A GIFT TO THE
PEOPLE OF SARASOTA
1941
A JUNIOR CHAMBER OF
COMMERCE PROJECT

John and Ida Chidsey donated $25,000 in 1941 for Sarasota's first official library building, located at 701 N. Tamiami Trail. The Junior Chamber of Commerce provided the furnishings for the library and adopted the project. The building was designed by Thomas Reed Martin, who also designed the renovation of Mrs. Potter Palmer's Osprey House in 1911. As Sarasota grew, Selby Public Library was built. Today, the Chidsey Library is used by the Sarasota County History Center, previously known as Sarasota County Historical Resources. This is a picture of John and Ida Chidsey at the building site of Sarasota's library during the cornerstone-laying ceremony. (Courtesy of the Sarasota County History Center.)

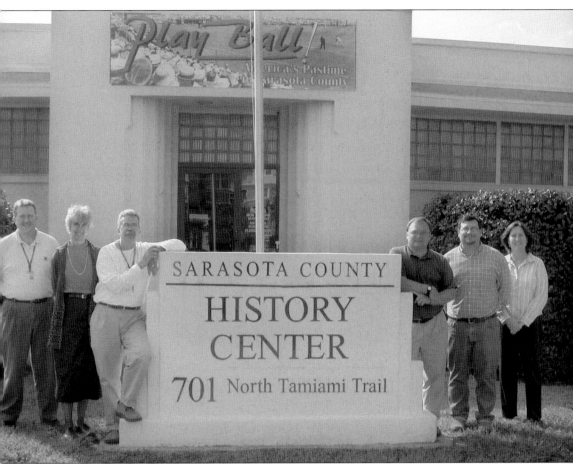

The Sarasota County History Center was started in 1958 by the Sarasota County Commissioners. The center provides several important functions to the community, including historical displays of local history and research opportunities. The building provides a large collection of books, papers, photographs, newspapers, maps, and a database. Programs promote the preservation of historical and archeological resources. The knowledgeable staff members give presentations throughout the community, educating people on Sarasota's interesting history. In this picture, from left to right, are Mark Smith, Ann Shank, Jeff LaHurd, Dave Baber, Dan Hughes, and Laurie Muldowney. (Courtesy of Amy Elder.)

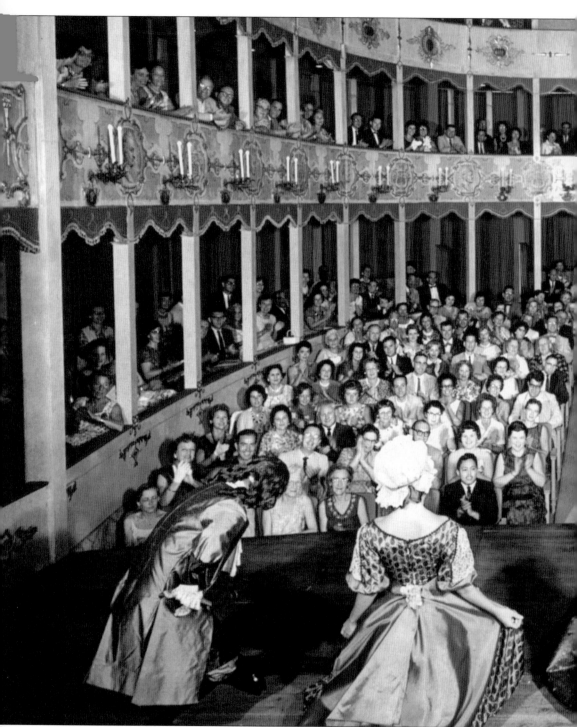

The Performing Asolo Theater is located at the John and Mable Ringling Museum of Art and is the only American-owned 18th-century European theater. The original Asolo Theater was a quaint 300-seat theater used for performances from 1960 until 1989. The interior was from an original court theater built in 1798 in Asolo, Italy, which was torn down in the late 1930s. Fortunately the interior

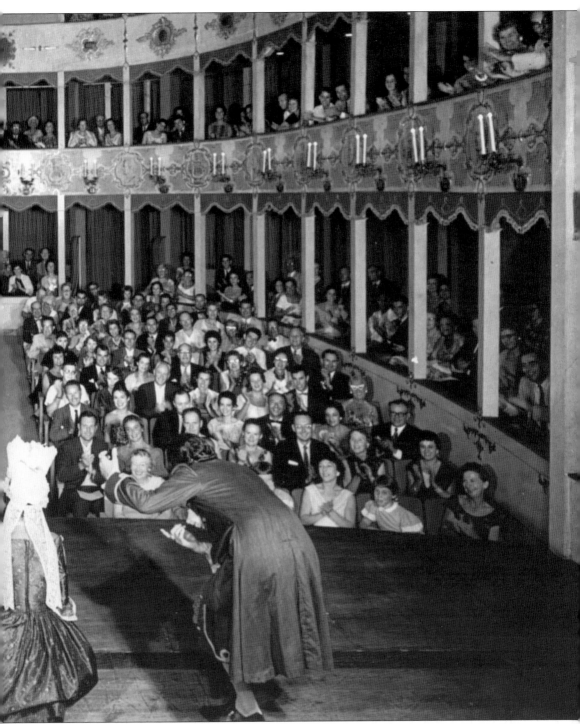

was saved, and the Ringling Museum purchased and rebuilt it in a structure located behind the museum here. The theater was first used in 1975 for a summer festival of Restoration-era comedies produced by Florida State University. (Courtesy of the Sarasota County History Center.)

The $15 million Asolo Center for the Performing Arts was built in 1989. The charming 500-seat theater incorporated architectural pieces from the interior of the Dunfermline Opera House, which came from Dunfermline, Scotland. The Scottish opera house had been torn down after it closed in 1955. A Sarasota architect, Stuart Berger, was thrilled to learn that these architectural pieces were available. Dunfermline is the sister city of Sarasota. This building is also where the Sarasota Ballet performs. (Courtesy of Amy Elder.)

The Sarasota Opera House was originally built as the Edwards Theater. A. B. Edwards, mayor of Sarasota and successful businessman, built the theater, which was used until 1970 for silent films, theater, and vaudeville acts. The Sarasota Opera Association purchased and renovated the building in 1979 and reopened it in 1993 as an opera house and to host community events. This building is listed in the National Register of Historic Places. (Courtesy of the Sarasota County History Center.)

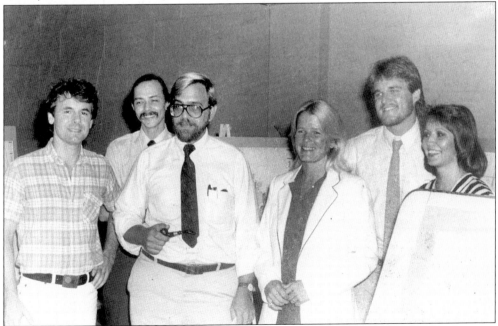

Here is a picture of the architectural team that redecorated the Edwards Theater into the Sarasota Opera House in the early 1980s. In the center, holding a pipe, is architect Michael Pack. (Courtesy of the Sarasota County History Center.)

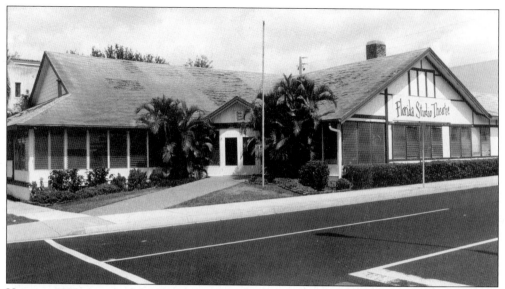

Here is a 1983 picture of the Florida Studio Theater (previously owned by the Woman's Club). The theater has offered the community of playwrights young and old, local and national, an opportunity to submit and perform plays. It offers classes and workshops, and in the spring has a play-writing contest for children and adults. In June 1993, a new building was started, located adjacent to the main stage theater building. A cabaret theater was added as well. The Florida Studio Theater has additional space in the old Theater Works building on First Street. (Courtesy of the Sarasota County History Center.)

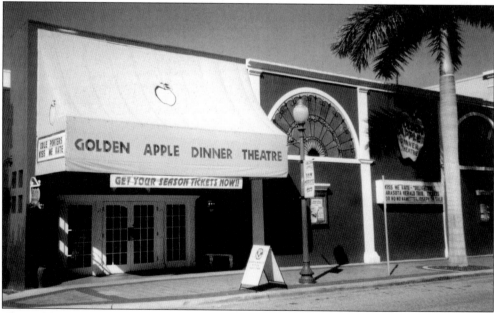

The Golden Apple Dinner Theater is located downtown at Five Points Park and has performed plays and musicals in Sarasota since 1971. Over 270 plays have been performed, including five originals. People return year after year to enjoy the buffet, friendly staff, and entertainment. Their chef and several of their wait staff have been there for over 25 years. (Courtesy of the Golden Apple Dinner Theater.)

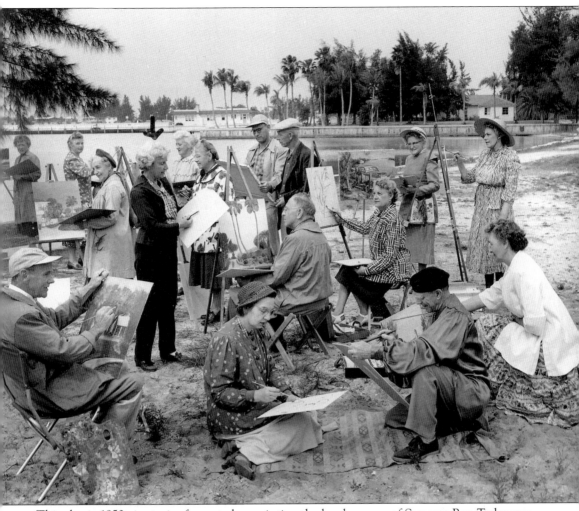

This classic 1950 picture is of an art class painting the local scenery of Sarasota Bay. Today you can still find art classes at Selby Gardens, Historic Spanish Point, and throughout Sarasota. (Courtesy of the Sarasota County History Center.)

Bernice "Brooksie" Bergen moved to Sarasota in 1939. Her father restored the Acacias, located on the bay on Yellow Bluffs. He also restored the crumbling antebellum mansion for her family. Bergen has always written journals, poetry, and essays, though, as a youth, she was sidetracked with theater and became a professional actress and model. She enjoys freelance writing but prefers writing essays. She also writes a weekly column for the *Herald Tribune* and is a monthly contributor to *Style*, *Attitudes*, *Downtown*, *Scene*, and industry magazines. Bergen has published a book on the history of Sarasota and another one on canoeing through Florida. In 1989, Bergen and her late husband founded an organization called Face, which helps people with craniofacial disorders. With the guidance of a professional, Bergen wrote 12 pamphlets that will be distributed nationwide about the issue. (Courtesy of Bernice Bergen.)

Eleanor Merritt moved to Sarasota in 1982 after living in the New York area all her life. She attended the High School of Music and Art and upon graduation attended Brooklyn College, majoring in fine arts and education. Merritt taught for 25 years before retiring to Sarasota and exhibited throughout the tri-state area from 1960 to 1980. She belongs to the National League of American Pen Women (NLAPW), the Women's Caucus for Art, and the Petticoat Painters. She has served on the board for the Sarasota Arts Council, the Ringling Museum of Art, the Selby Community Foundations, and the Sarasota Art Center. Merritt is currently the chair of the Art in Public Places program for Sarasota. Merritt continues to experiment in mixed-media techniques. She is currently working on her 25th one-woman show. This picture shows her working in her studio. (Courtesy of Eleanor Merritt.)

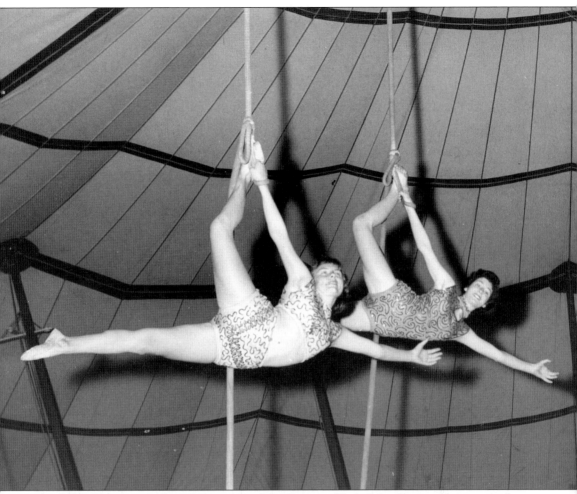

The Sailor Circus started in 1949 as part of the Sarasota High School's gymnastics team. It is the only program of its kind that was founded and funded by a school district. Today the Sailor Circus is run by the Police Athletic League. In 1952, the Sailor Circus was given permission from the Ringling Brothers and Barnum and Bailey Circus to call itself "The Greatest Little Show on Earth." Each March, students produce a show in the large blue and white "big top" located on Bahia Vista. This is a wonderful tradition and unique high school experience for many students. Some of the teachers were from the Ringling and Barnum Circus, which was located in Sarasota County from 1927 to 1989. (Courtesy of the Sarasota County History Center.)

The Jazz Club of Sarasota was founded by Hal Davis and his wife Evelyn in 1980 to "promote, preserve, perform, and educate people about jazz." In 1980, a group of residents from Pelican Cove got together to listen to jazz and socialize. Jean Germain said the Davises invited her over and asked her to bring her Benny Goodman recordings. The original group started out in the Davises' apartment and eventually moved as the group increased. Some of their locations were the Fortune Federal Bank, the Sarasota High School, the Sarasota Opera House, and finally the Van Wezel. The club offers educational programs including the Artists-In-Residence program, which brings well-known musicians to area schools. Shown here is Germain with Milt Hinton. (Courtesy of Jean Germain.)

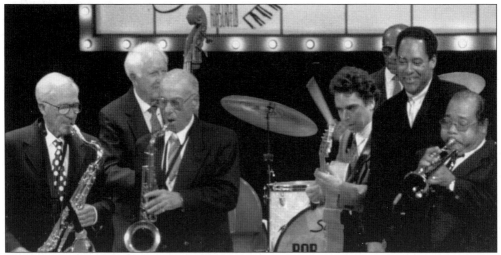

The Sarasota Jazz Festival is sponsored by the Sarasota Jazz Club. This year, they celebrated their 24th anniversary with the theme "Straight Ahead for Jazz," and popular bands such as Dizzy Gillespie Big Band All-Star Alumni played. Great jazz can be heard throughout Sarasota, especially at the Phillippi Estate Park on the bay front and at the Van Wezel. Fortunately Germain spent 25 years photographing and documenting jazz musicians from the sixth row of the Van Wezel with no flash or tripod. Pictured here are Jerry Jermane on saxophone, Bob Haggart on bass, ? Phillips on saxophone, Howard Adler on guitar, ? Jackson on drums, Jon Faddis (observing), and Nat Adderley on trumpet. (Courtesy of Jean Germain.)

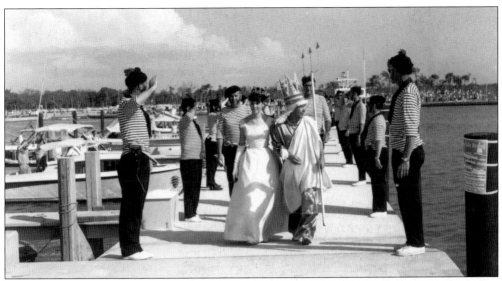

The King Neptune Festival started as an extension of the Sara de Soto Pageant, which first started in 1918. The name changed to the Orange Blossom Festival and then to the Sarasota Pageant. In 1957, the theme was changed again to honor the Scottish who arrived in Sarasota in 1886. Finally the King Neptune Frolics came to be in 1968. It represented multiple themes, including the Scottish, Spanish, circus, and artistic cultural heritage of the town. (Courtesy of the Sarasota County History Center.)

The King Neptune Parade was a fun community event. The festival included sporting events, parades, and dinners. During 1984, the Tampa Bay Buccaneers football team marched in the parade and threw out team souvenir cards. Pictured here in 1981 are Joanne and George Heiland with their family. They are the owners of Blue Line, Inc., located at 301 Central Avenue. As 1981 was the last year of the parade, they are the reigning queen and king. (Courtesy of the Sarasota County History Center George Heiland Collection.)

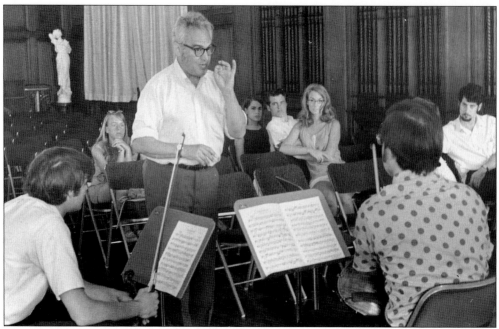

The New College Chamber Music Festival was started by the Sarasota Symphony and New College in 1965. In 2005, they celebrated their 40th anniversary. Both college students and professional musicians participate in the festival, which provides students the opportunity to work with musicians in their field. The event grew into a three-week long event, and in 1984, Florida acknowledged the festival as the Official Teaching and Performing Festival. (Courtesy of the Sarasota County History Center.)

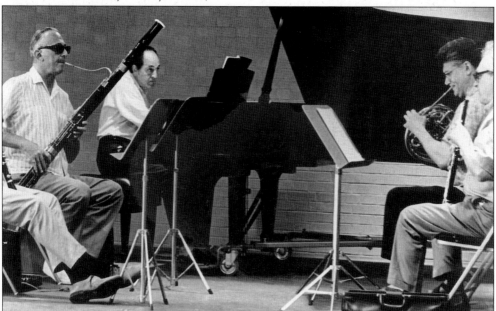

Paul Wolfe has been the artistic director for the New College Chamber Music Festival since its inception. Pictured here is a group of musicians performing. (Courtesy of the Sarasota County History Center.)

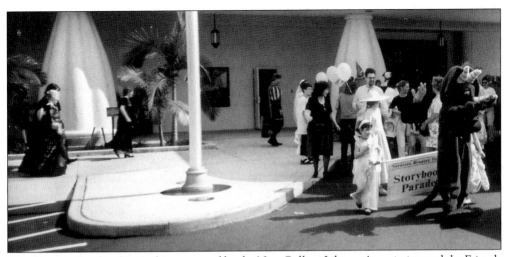

The Sarasota Reading Festival is sponsored by the New College Library Association and the Friends of the Selby Public Library. For the past seven years, Sarasota has celebrated the Reading Festival in November. Five Points Park becomes a cultural mecca for fun activities for all ages. The Golden Apple, Sarasota Opera House, and Selby Library all provide space for different cultural activities. Famous authors come from around the country to give book talks and discussions. Pictured here is author Amy A. Elder dressed up as Liz the Lizard from the Magic School Bus series leading the storybook parade in front of Selby Library (the costume is compliments of Circle Books of St. Armands). (Courtesy of Amy Elder.)

Sarasota has had a handful of film festivals over the years, including the Black Film Festival, Sarasota Film Festival, French Film Festival, Lesbian and Gay Film Festival, and the Cine-World Film Festival. Today the two remaining festivals are the Cine-World Film Festival and the Sarasota Film Festival. Both offer great entertainment for the community. The Sarasota Film Festival occurs in late January. It offers entertaining family activities, including outdoor screening and street fairs as well as luncheons and dinners to honor actors. The movies are played at the Main Street Hollywood 20 Theater. The sophisticated Cine-World Film Festival features independent and foreign films. For 10 days each November, people flock to watch films at the Burns Court Theater. The theater district is located in Burns Court and was developed by Owen Burns in the early 20th century. (Courtesy of the Sarasota County History Center.)

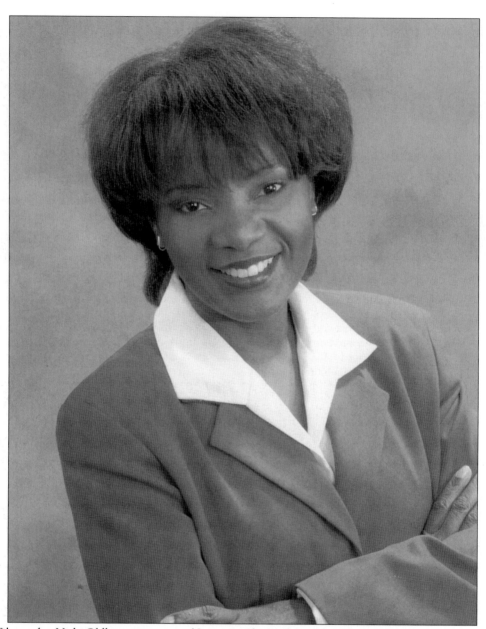

Film maker Vicki Oldham is a native of Sarasota. She graduated from Riverview High School and then went on to get her bachelor's degree in journalism and communications at the University of Florida. She received her master of fine arts from Florida State. Oldham has been in the media business for 27 years. She has reported the news, hosted shows, produced and written, and has done marketing and public relations. She currently is hosting a show called *Inside Sarasota Government* and producing a show called *Eye on Education*, which is hosted by school superintendent Dr. Gary Norris. Another project that she is excited about is called *Angola*. She is spearheading an archeological study along the Manatee River. Historians, archeologists, and anthropologists believe a black settlement called Angola existed along the river from 1812 to 1821. Oldham has written and received three grants for the project. Oldham is an active mentor to countless teenagers and college students throughout Sarasota. (Courtesy of Vicki Oldham.)

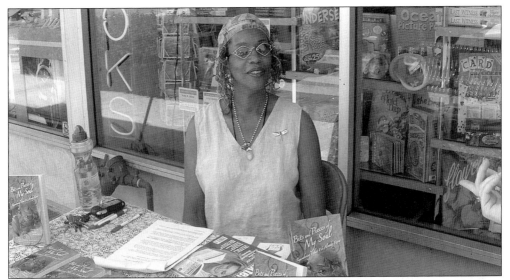

Carolyn M. Dixon, M.D. moved to Sarasota in 1984 with the goal of establishing an OB/Gyn practice. She is the first African American female physician to practice in Sarasota and be on staff at both Doctors Hospital and Sarasota Memorial Hospital. Dixon is multi-talented. She wrote a column on alternative healing for the *Sarasota Herald Tribune*, published a few books, is an ordained minister, and is a doctor. She is a spiritual woman who shares her many talents with the community both as a teacher and mentor to young and old alike. (Courtesy of Harold Zieger.)

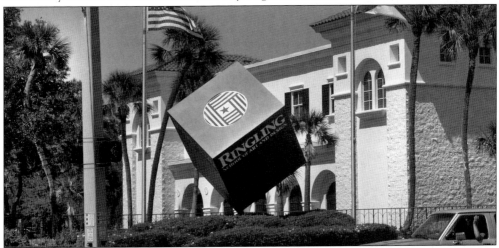

The Ringling School of Art and Design was founded in 1931, during the Depression, and was originally part of Southern College (now Florida Southern College). When college president Ludd Spivey called John Ringling for a donation, Ringling convinced him to build a satellite school in Sarasota. He took the responsibility of finding and renovating space for the school at the Bay Haven Hotel. Talented artists Hilton Leech and George Pears Ennis were on the original faculty of the art school. In 1933, the school became independent. Many other art schools were established in the 1940s and 1950s. A few were the Farnsworth School in 1941, the Amagansett in 1948, The Hartman School of Art in 1952, and The Chase School of Art. Today the college offers four-year bachelor's degrees in computer animation, fine arts, graphic design, and photography. Shown here is a Ringling School building located on Martin Luther King Jr. Boulevard. (Courtesy of Amy Elder.)

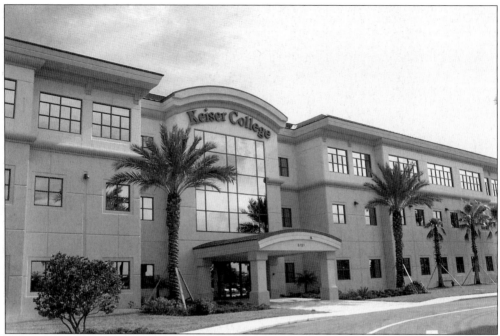

Keiser College is a satellite school of the Keiser College Fort Lauderdale campus. For 25 years, it has been offering career education. They now offer online associate of arts and bachelor of arts degrees in four main categories: medical, legal, technical, and business. Their philosophy is a "one class at a time approach." (Courtesy of Keiser College, Todd Deangelis Collection.)

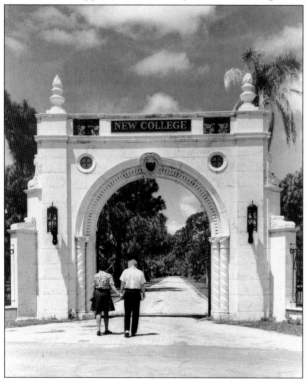

New College was built on a 115-acre estate in Sarasota. The first class enrolled in 1964, and the first president was George Fetching Baughman. Baughman helped raise money, find faculty, and worked with the community to help start this privately funded school of liberal arts and sciences. He was responsible for heading up and running the New College Foundation. Dr. Howard Spragg claimed the school was named after New College in Edinburgh, Scotland, but later the college and foundation claimed it was named and modeled after New College in Oxford, England. (Courtesy of the Sarasota County History Center.)

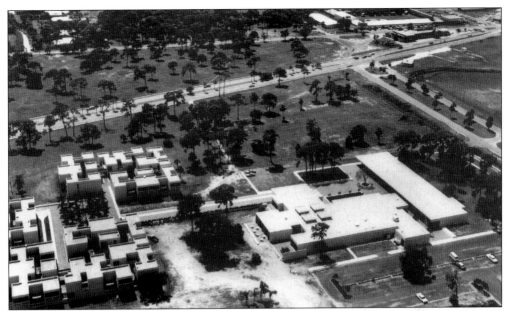

New College started as a private four-year liberal-arts school thanks to partnership with the United Church of Christ (UCC). Rev. John McNeil, from the Sarasota Congregational Church UCC, rallied to have the UCC start a college in Sarasota. In 1959, he was on the committee to negotiate terms for the school. Chamber of Commerce manager Todd Swalm wanted the new college to be "unique in many phases of operation and orientation, to the end that it will achieve national recognition and stature to attract outstanding students from the 50 states to come to Sarasota for their own college-level education." In 1975, the school joined the state system. The east side of the campus was designed by the famous Chinese architect Ieoh Ming (I. M.) Pei. (Courtesy of the Sarasota County History Center.)

The University of South Florida's main campus is in Tampa with several branches throughout the state. One of these branches is located in Sarasota. The college is looking to expand and move the campus from New College to the Crosley Estate. The Sarasota Campus enrollment has grown to over 3,000 students, which is a 50-percent increase since 2001. (Courtesy of Amy Elder.)

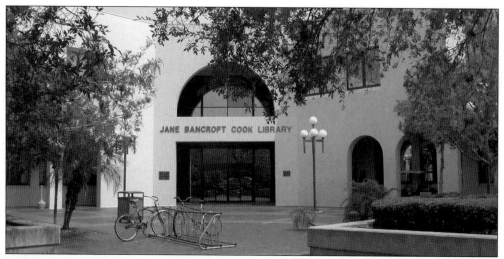

Jane Bancroft Cook Library is an educational and cultural resource for the University of South Florida Sarasota/Manatee campus, the New College of Florida campus, and communities within Manatee and Sarasota County. A library was started in 1963 with the inception of New College. In 1975, New College was purchased by the state university system, and the library systems merged. Finally, in 1986, a new library was built to meet the growing needs of the colleges and community. Today the library offers "The Virtual Library," which includes databases, abstracts, and full-text/image documents. (Courtesy of Amy Elder.)

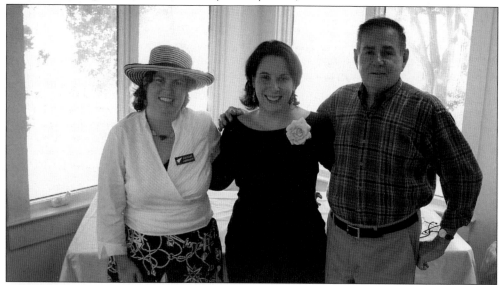

The Historic Spanish Point Research Library was opened to the public on Valentine's Day of 2005. Curator Karen Bilky put together a committee in the spring of 2004. Retired librarian administrator Fred Dudda, author Amy A. Elder, and Bilky cataloged the donated materials and had a festive opening on January 8. The library is located in White Cottage, which was built by the John Webb family and then belonged to Gordon and Janis Palmer, who lived there as late as the 1970s. The library has a collection of nautical, local, and pioneering history, and archeology books, papers, and a large collection of old photographs dating back to 1867, when the Webb Family first moved to Osprey (Little Sarasota Bay). Pictured from left to right are author Amy Elder, Karen Bilky, and Fred Dudda. (Courtesy of David Keane.)

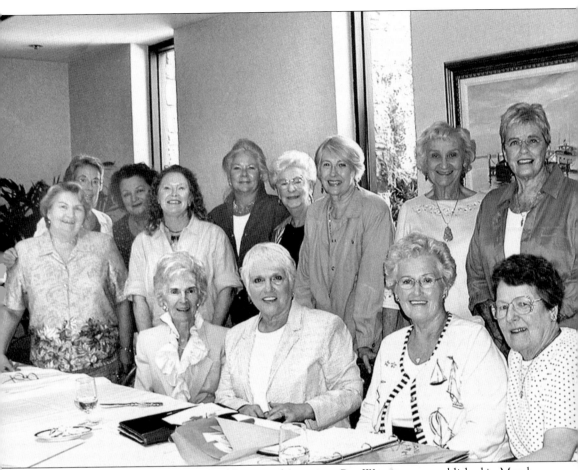

The Sarasota branch of the National League of American Pen Women was established in March 1957. The national organization began in Washington, D.C., in 1897, after three journalists were excluded from joining the Washington Press Club (National Press Club). Like other branches around the United States, Sarasota opened a chapter for professional women who are talented in the arts, music, or writing. The National League of American Pen Women meet throughout the year to share their work, discuss new trends, network, and give their support to fellow members. There is a group of patrons who are involved and donate generously to the arts community and to the branch's college scholarship awards program. Each year, seniors in the public schools can enter a writing, art, or music competition. Board members from left to right are the following: (first row) Betty Altman, Barbara Hansen, Barbara Thelen, and A. Eileen O'Con; (second row) Halide K. Smith, Sue Anderson, Barbara Schicitano, Kathleen McDonald, Elizabeth Van Riper, Nell Rude, Alice Boudreau, Dr. Norma Compton, and Jane Dye. (Courtesy of A. Eileen O'Con.)

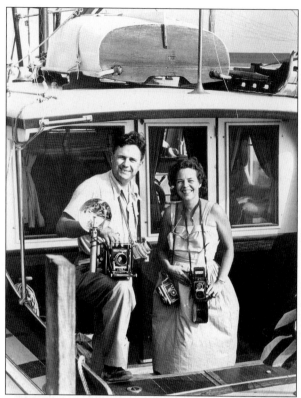

Photographer Joseph Steinmetz moved to Sarasota in 1942 with his family. A graduate of Princeton University, Steinmetz chose to go into photography rather than follow his English degree. Before moving here, he photographed weddings and formal affairs for the upper crust in Pennsylvania. He also published his work in the *Saturday Evening Post*, *Life*, *Time*, and *Town and Country* magazines. He photographed Sarasota as it was, unpretentious and relaxed. His photographs captured people wearing shorts and bathing suits, enjoying the local beaches, playing golf, and living in trailer parks. Although Steinmetz died in 1985, his name lives on through the Joseph Janney Steinmetz Memorial Photo Award, which is given to the best-in-show winner at the annual Marie Selby Botanical Gardens Photo Contest. (Courtesy of the Sarasota County History Center.)

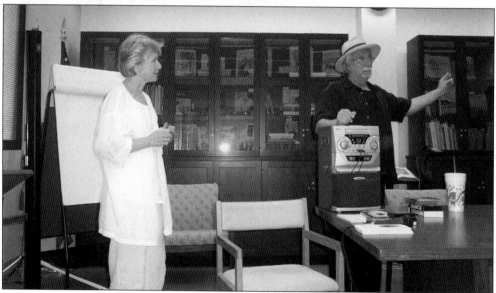

Soulspeak is based on ancient poetry that was used before people learned how to read or write. This type of poetry consists of a simple story or poem that is spontaneous, rhythmic music using a speaker and a responder. Soulspeak has been performed all over the state of Florida and has great success working with at-risk children. Companies and schools can have them come to work with small groups on poetry and for sensitivity training. Pictured here are founders Scylla Liscombe and Justin Spring during National Library Week at New College. (Courtesy of Amy Elder.)

Artist Richard Capes came to Sarasota in 1974. Before moving here, he taught art and graphic design at the University of Mississippi and Morehead State University in Kentucky. Fortunately for Sarasota, Capes has historical interests in the area and has captured many local scenes and architecture with his brush over the years. Several of the buildings he painted have been torn down, including the John Ringling Towers. He wrote and published a book on Siesta Key using his watercolors as illustrations. City Hall gave him a plaque for his rendition of the Municipal Auditorium and the Hazzard Fountain. Capes is a member of the Florida Artist Group, Inc., which travels throughout the country. He is supportive of the Sarasota arts community and has mentored local artists. (Courtesy of Judy Fiala.)

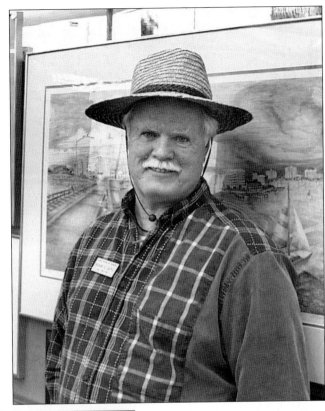

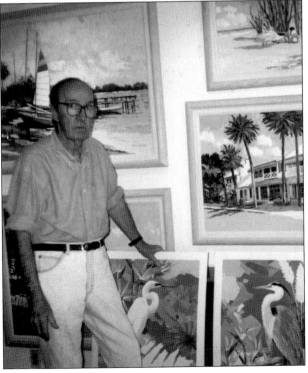

Artist John Dineen's work can be seen all over Sarasota. He captures the local color with acrylic paint on canvas using a pallet knife and brush. He likes to work with bright and intense colors. Since he moved to Sarasota, he has been painting the beautiful scenery and making posters from them, 13 in all. Dineen's work can be found in local government buildings and in over 200 corporate and private collections. After graduating from the Massachusetts College of Fine Arts in Boston, he worked in the advertising business. At 25, he decided to paint full-time. Dineen started wintering in Sarasota in 1955 and owned a gallery on St. Armands Circle for several years. Dineen's work expresses great depth, sophistication, and vitality. (Courtesy of John Dineen.)

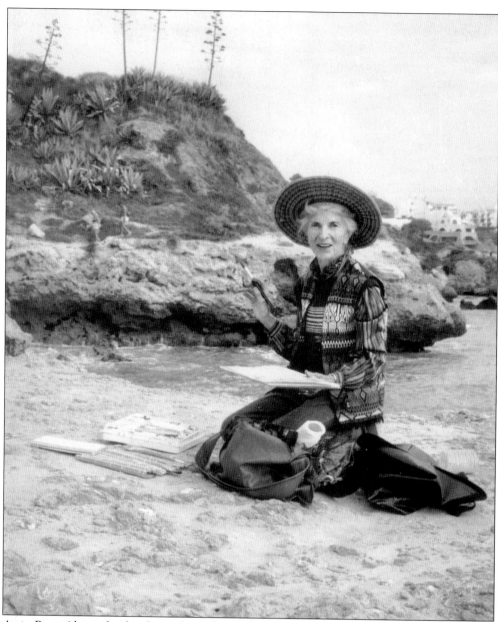

Artist Betty Altman has lived in Nokomis since the mid-1970s. Her formal schooling was at the Art Institute as a figurative oil painter. When she first moved to Sarasota, she lived on Longboat Key and studied with Eldon Rowland in Riverwoods and with Leona Sherwood of Longboat Key. In the mid-1970s, she joined together with a talented group of artists called Art Uptown, Inc., and opened a studio on Main Street. Altman's fresh and unique style can be explained by the fact that she never stops taking lessons and trying new mediums. She is very committed to Sarasota and the art culture of the area. She is involved with the Sarasota Art Association, Women's Caucus for Art (WCA), Venice Art Center, the National League of American Pen Women Awards program for gifted high-school students, the Longboat Art Center, and the Manatee Art Center. She encourages artists of all ages to continue to grow and learn in their craft. Altman has traveled the world taking art classes. This picture is taken of Altman painting on a beach in Portugal. (Courtesy of Betty Altman.)

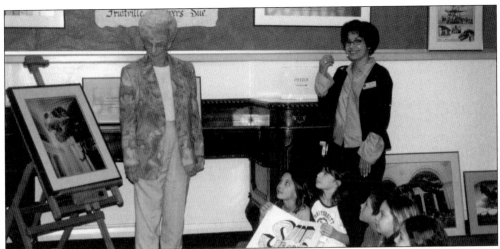

Photographer Nell Rude first started wintering in Sarasota in 1978. She met photographer Bob Wands in 1978 when she went into Selby Gardens to inquire about a membership. Rude has taken lessons from Wands, Margaret Meade, and a photographer from the Smithsonian, all offered at Selby Gardens. She is part of several local art organizations and has won national and local awards over the last 20 years. Rude has a diverse style. She started out with nature scenes, including birds and flowers, and has expanded into abstracts and reflections. Rude donated a series of photographs of the dinosaur at the Field Museum to the Sarasota School Board, which traveled throughout the system educating children on dinosaurs. The exhibit, called "T-Rex Sue," was named after Sue Henderson, who discovered the dinosaur bones in South Dakota that were purchased by the Field Museum in Chicago. Pictured here is Nell Rude at Fruitville Elementary. (Courtesy of Nell Rude.)

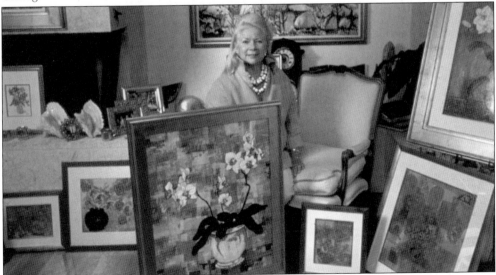

Artist Elizabeth Van Riper moved to Sarasota in 2001 from Dallas, Texas. She is a fourth-generation, mixed-media artist who, in the past couple of years, has been creating beautiful orchid collages. Van Riper believes that the residents in Sarasota who value the influence of the arts have an obligation to support the organizations and people that make the arts thrive, thus ensuring their perpetuity. As a visual-arts activist, she is affiliated with many professional art organizations that have various levels of community outreach efforts. She was the moderator of a successful art forum called smARTalk. (Courtesy of Elizabeth Van Riper.)

Sculptor Jack Dowd moved to Sarasota in 1982. Before moving here, he lived and worked in Long Island and New York City as a restaurant and bar owner. This experience inspired him to make his sculpture of a bar scene based on real characters he knows. While in New York, he met is wife, Jill. Fate brought them together when he left something in a phone booth and returned to retrieve it. Dowd is supportive of the community and is involved in several charities, including Boys and Girls Club, Make a Wish Foundation, and local schools. (Courtesy of Giovanni Lunardi.)

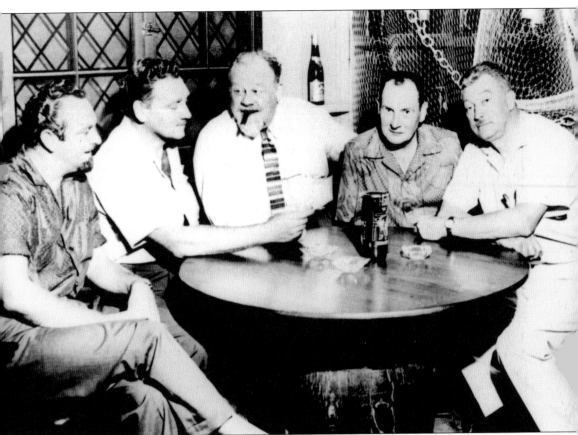

Many famous and not-so-famous writers have gravitated to Sarasota to live and write. And just like 50 years ago, there are some writers who want to be left alone to write. Fortunately, there was one writer named Mackinlay Kantor, who wanted to get together and socialize with other local authors. In 1952, he invited four other authors to join him for lunch, poker, and fun. Since then, over 200 authors have come together to socialize with the "Liars Club." Local author Wayne Barcomb has been attending the group when in town. Whoever lost at the game of "Liars Poker" had to buy the round of drinks that week. Here is a group picture of writers taken at the Buccaneer Inn on Longboat Key. From left to right are Ronnie Holliman, Herb Field, Burl Ives, Dick Glendinnig, and Mackinlay Kantor. (Courtesy of the Sarasota History Center.)

Author Mackinlay Kantor and his wife built a house on Siesta Key in 1937. A naturalist, Kantor did not use heat or air-conditioning nor did he own a television. He was a war correspondent during World War II and the Korean War. During his writing career, which started early with his first published novel at age 24, Kantor went to Hollywood to work on the screenplay *The Best Years of Our Lives*, which was based on his novel *Glory for Me*. Kantor's best-known novel was *Andersonville*, which won the Pulitzer Prize in fiction in 1956. The book was set during the Civil War in a concentration camp, where his great-uncle had been. This picture of author Mackinlay Kantor was taken for his book *Andersonville*. (Courtesy of the Sarasota County History Center.)

Author J. D. McDonald moved to Sarasota in 1951 and wrote about Florida in his mystery books. While living here, he wrote 70 novels and over 200 short stories. His *Travis McGee* novels are still popular today. Like his fellow writer and friend Mackinlay Kantor, McDonald cared about the environment and growth of Sarasota. He served on the board of the New College Foundation and donated his written work to the University of Florida. McDonald lived in Sarasota for 35 years. (Courtesy of the Sarasota County History Center.)

Petey Swalm moved to Sarasota in the early 20th century. She was very young when she arrived with her siblings and parents. They lived in a two-story house between Fruitville and Main Street called Linger-Longer, which had its own engine to generate electricity. Built in 1909, the house had lots of porches and few neighbors. The population in Sarasota then was less than 1,000. Petey and her family left the area in her late teens, but she returned to Florida to write in 1944. During the 50th anniversary of Sarasota in 1952, she wrote a musical called *Of These Sands*, which was performed throughout the week. Two other books that she wrote about Sarasota are *Once Upon a Morning* and *Molly Boots*. Pictured here is author Neil "Petey" Chapline Swalm with second husband Todd in 1952. (Courtesy of the Sarasota County History Center.)

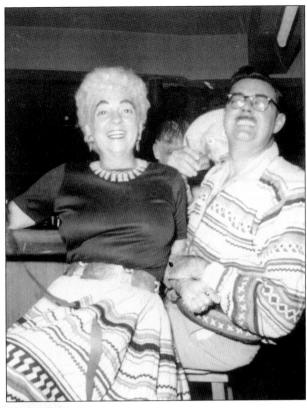

Playwright Barbara Anton moved to Sarasota from New Jersey in 1987. She owned a retail jewelry store in Englewood and designed and sold jewelry during the 1960s and 1970s before retiring. Anton took a class with Jack Fournier at Florida Studio Theater (FST). Her plays have been performed and have won awards locally (she won 14 short contests at FST from 1995 to 2001, when the contest was discontinued). She has also been performed in 34 productions in New York City, as well as Pennsylvania, Charlestown, Los Angeles, and Las Vegas. Anton is modest about her success and has contributed to the community by teaching writing at the University of South Florida (senior division) and sponsoring a writing contest at FST to encourage other playwrights. (Courtesy of Barbara Anton.)

Illustrator Frank Remkiewicz moved to Sarasota in 1994 from Sonoma Valley in California. He attended the Art Center College of Design in Los Angeles and moved to New York City to work for an advertising agency. His design graced the animal cracker box for several years. Remkiewicz has written six books and illustrated over 80. He is most recognized for his illustrations in the *Froggy and Horrible Harry* series. Remkiewicz has worked with the local schools and libraries by educating children on the process of book writing and illustrating. (Courtesy of Frank Remkiewicz.)

Author Stuart Kaminsky has been writing since he was 12 years old. As the author of 50 published novels, 5 biographies, 4 textbooks, and 35 short stories, and with screenwriting credits for 4 films, he continues to enjoy writing. He taught for 16 years at Northwestern University before becoming a professor at Florida State, where he headed the Graduate Conservatory Program in Film and Television Production; he left there in 1994 to be a full-time writer. Kaminsky moved to Sarasota in 1989. He is a member of the Liars Club, Libertarian Club of Sarasota, Sarasota Fiction Writers, and Mystery Writers of America. He offers a film discussion monthly at Barnes and Noble. (Courtesy of Stuart Kaminsky.)

Three

COMMUNITY

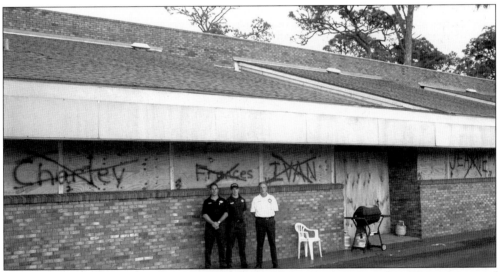

The year 2004 featured the hurricane season that will never be forgotten along the west coast of Florida. Four hurricanes, named Charlie, Francis, Ivan, and Jeanne, pummeled the area, leaving thousands of people without electricity, houses, boats, and even their lives. Lt. Terry Marshall, from the Sarasota Fire Department Station #11, was on duty during Hurricanes Frances and Jeanne. On Sunday, September 5, 2004, Francis hit the county, and Marshall received 30 calls in less than 24 hours due to fires or fire alarms going off. On September 26, when Hurricane Jeanne hit, Marshall received 27 calls with two confirmed structure fires. While putting out a fire on Siesta Key, he saw the waves from the Gulf of Mexico were breaking over the back of the house. From left to right, paramedic Pete Zappulla, paramedic Hank Duyn, and Lt. Terry Marshall are shown in front of their temporary fire station. They will be moving to a new station on Stickney Point Road in 2005. (Courtesy of Amy Elder.)

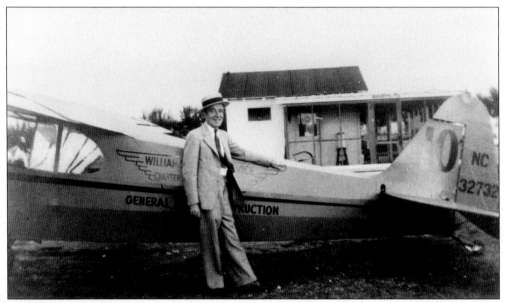

The First Municipal Airport was used mostly for recreational flying until World War II, when the Civil Air Patrol (CAP) took over. The CAP would scout across the Gulf of Mexico looking for German submarines and would help escort ships into Tampa Bay. In the rainy season, small planes used skids in place of the tail wheel to slow them down. Pictured here is Fred Francke, first travel agent and realtor in Sarasota. (Courtesy of the Sarasota County History Center.)

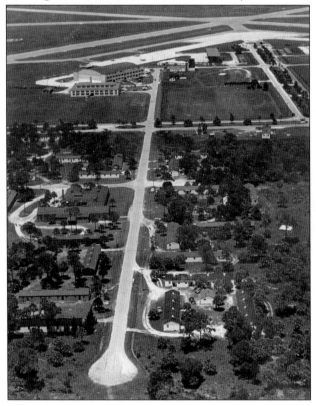

The Sarasota-Bradenton International Airport began in 1938 as one of Roosevelt's WPA projects. During World War II, the U.S. Army took over the airport and finished construction in 1942. Barracks were built on part of the land. After the war, the airport was given back to the Sarasota-Manatee Airport Authority. In order to expand, they approved building another terminal, which was designed by architect Paul Rudolph. The new terminal was dedicated in 1959 and was used until a larger terminal would be built in 1989. (Courtesy of the Sarasota County History Center.)

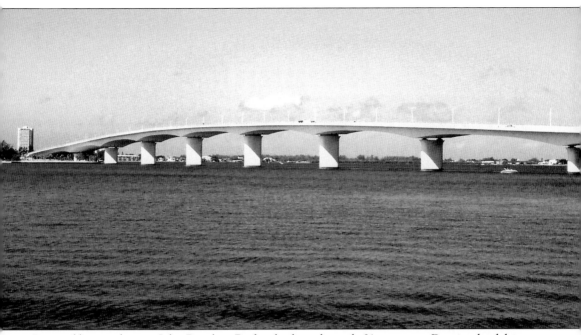

Pictured here is the new John Ringling Bridge, built in the early 21st century. Despite the debate over the style and height of the new bridge, traffic is moving better both on land and water. Many enjoy exercising by walking, running, or bicycling on its sidewalks and bike paths. (Courtesy of Raymond Hutchins.)

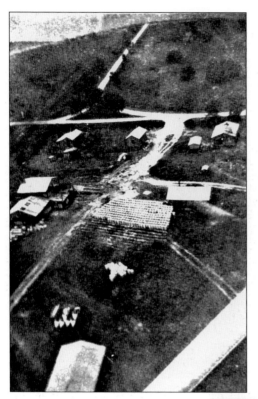

The Bee Ridge Turpentine Camp, which opened in the late 1930s, ran until 1952. Berryman Thomas "B. T." Longino Sr. and Luther Franklin "Luke" Grubbs opened and ran the camp. Workers, who were mostly African American, lived and shopped at the camp, which was located at the intersection of Clark and McIntosh Roads. The conditions were difficult and included hard work and little freedom under the constant supervision of the foreman. Workers attended the Mount Moriah Baptist Church for their social, educational, and spiritual needs. (Courtesy of the Sarasota County History Center.)

A. J. (Pat) and Betty Melville brought thousands of bees to Sarasota from Canada and started the Sun Fed Honey business. They owned the Shangri-La Groves off of Clark Road and started their business in a small wooden shed. They also had beehives in Georgia and north Florida. The Melvilles wanted to educate the public on the life of bees and how to make honey. They created a traveling show called the "City of Bees" and sent it to Macy's Department Store in New York City. They also created a "Chest of Drawers Hive." During the 1950s and 1960s, the company supplied a chain of Florida supermarkets with honey and continued the business into the 1970s. (Courtesy of the Sarasota County History Center.)

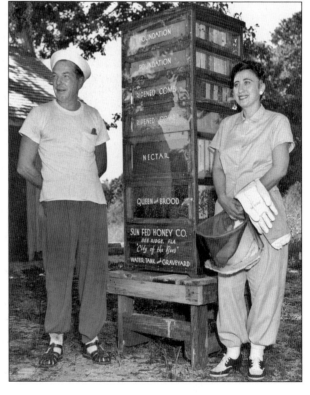

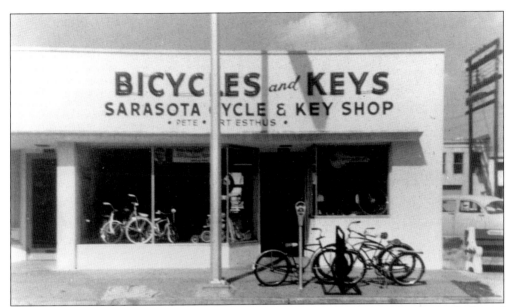

The Sarasota Typewriter and Key Shop (also called Bicycles and Keys and Sarasota Cycle and Key Shop) was founded by George Esthus's parents, Arthur and Clara Esthus, in 1925. George I. "Pete" Esthus purchased the business from his parents in 1962, and in 1969, he sold the bicycle-repair end of the business and changed the name to the Sarasota Lock and Key Shop. (Courtesy of George I. "Pete" Esthus.)

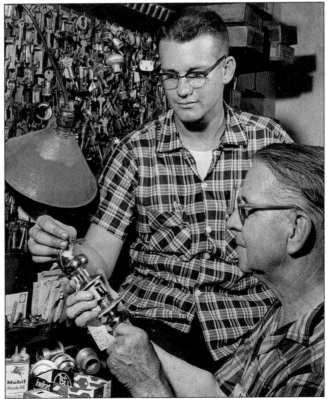

While having keys made, people enjoyed learning about Sarasota's history from the large display of articles and pictures at Sarasota Lock and Key Shop. Esthus misses having the opportunity to display and share all of the historical photographs and articles that he collected over the years. The shop is seen here located on State Street. It was first located on Main Street (from 1925 to 1935), then moved to Central Avenue (from 1935 to 1951), before finally moving to State Street, where it remained from 1951 to 2004. Here is a picture of George "Pete" Esthus with his father, Arthur Esthus, in their shop. (Courtesy of George I. "Pete" Esthus.)

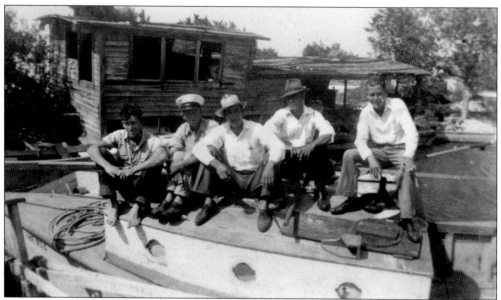

The Siesta Key Fish Market was started by James Alonzo "Lonni" Blount and his wife, Ida. Located on the north end of Siesta Key, they sold smoked or fresh fish and other seafood that they caught or purchased from local fishermen. In the 1930s and 1940s, visitors and residents, including the Boston Red Sox, enjoyed meeting and socializing at the market. (Courtesy of the Sarasota County History Center.)

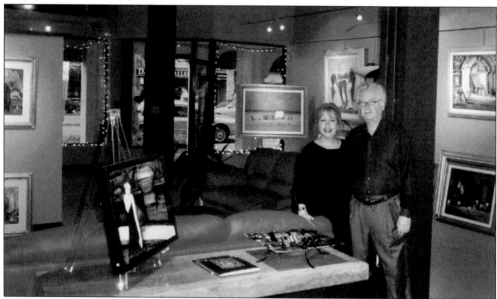

Medici Gallery is located at 75 South Palm Avenue. This unique gallery specializes in fine European art from Italy. Owners Joan and Robert (Bob) Rubenstein moved here from Carmel, California, in 2003. They have been collecting and selling Italian art for 25 years and had a gallery in Carmel. Bob studies the lives of artists and is always looking for that "spark of genius." They collect paintings that have life and meaning, tell a story, and capture the human experience. Each painting, by artists such as Fabio Calvetti, Ugo Nespolo, and Bruno Paoli, are original masterpieces. Pictured here are the Rubensteins in their gallery. (Courtesy of Medici Gallery.)

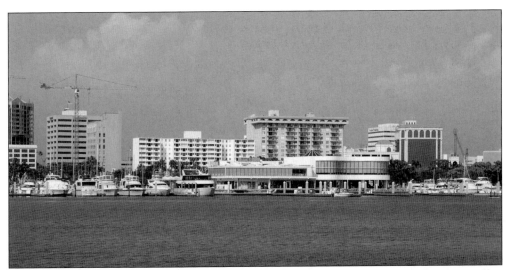

Marina Jack Restaurant is located in the heart of the downtown waterfront. The restaurant offers several dining rooms and a banquet room, all of which have spectacular views of Sarasota Bay and the Intercoastal Waterway. The *Marina Jack II* dinner boat takes people for a cruise around the bay while diners enjoy their dinners. They have a full-service marina that accommodates transient and year-round boaters. The owners and staff are committed to helping and improving the community and environment. (Courtesy of Douglas C. Elder.)

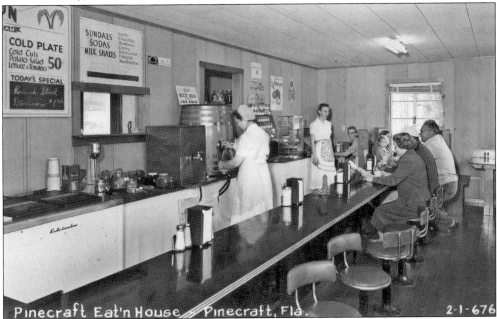

The Pinecraft Eat'n House was located on Bahia Vista Road. This was a popular Amish-style-food restaurant. The Amish and Mennonite communities have grown since the settlers first arrived in the 1920s. The National Tourist Corporation laid out 454 plots, each measuring 40 feet by 40 feet, south of Bahia Vista and Philippi Creek in the 1920s. In 1926, Earl and Mary Craft platted Pinecraft and added land to the community located east and west of Philippi Creek. Today, Pinecraft is a term used to describe the Amish community. (Courtesy of the Sarasota County History Center.)

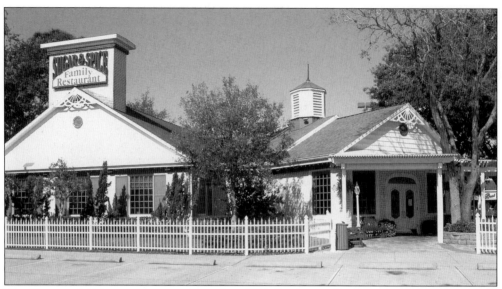

The Sugar and Spice restaurant is located at 4000 Cattlemen Road in Sarasota. The original owners, Ruben and Rosemary Beachy, moved here from Sugarcreek, Ohio, in 1983 and opened their restaurant in 1984. Sugar and Spice was first located on Tamiami Trail near the hospital and was there for many years. When Sarasota Memorial Hospital needed to expand, the restaurant lost their lease. Today Sugar and Spice has a new and modern location that serves delicious Amish-style cooking. They are also known for their homemade pies, with over a dozen from which to choose. Family, friends, and tourists are welcomed and treated like family. (Courtesy of Amy Elder.)

Tervis Tumbler is located in Osprey on U.S. 41. In 1946, two engineers named Cotter and Davis invented insulated tumblers. They combined the end of their names to make the name Tervis. The double-layer of plastic keeps drinks either hot or cold by harnessing the insulation properties in air. Floridians and people in other parts of the country love using these plastic tumblers because they do not sweat, so there is no need for coasters, and if for some reason the tumbler is damaged, it can be returned for a replacement. Products have a lifetime guarantee. (Courtesy of Amy Elder.)

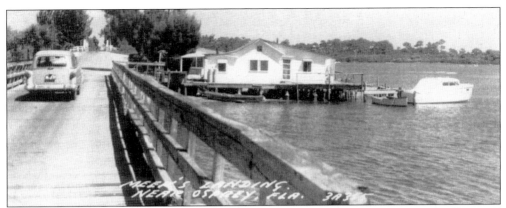

The Casey Key Fish House is located on Blackburn Point Road. The building was originally owned by the Meeks. Meeks Landing was home to many businesses including a bait shop, sandwich shop, the Salty Dog Restaurant, Captains Cove, Walt's Fish Market, and a marina that also sold boats. This picture of the property was taken in the 1950s. Notice the old wooden bridge. (Courtesy of James Von Hubert.)

James "Jimmy" Von Hubert purchased Meeks Landing in 1999 and opened the Casey Key Fish House. Fortunately, he was able to clean the place up without losing the old Florida charm. While waiting for dinner, children young and old enjoy walking the docks and admiring the view. This is one of the remaining restaurants in the area that you arrive at by boat or car. Here is a picture of patrons enjoying the environment at the tiki bar. Employees like "Skeeter" and "Chef Willie" have been part of the action since the beginning. Skeeter and Van Hubert have been involved with raising money for local charities and hurricane victims. (Courtesy of Tom "T. C." Corley.)

The Pelican Man Bird Sanctuary was established in 1980 by Dale Shields, "The Pelican Man." His mission was to treat and help wildlife in distress, and he helped save thousands of injured pelicans as well as other migrating and native birds. Although he has passed away, his large non-profit organization continues on. Guests can visit the sanctuary on City Island near Mote Marine Laboratory. (Courtesy of the Sarasota County History Center.)

The Morning Crew of Oldies 108 WSRZ FM with David Jones and Christina Crane began broadcasting April 3, 1995. Over the past 10 years, these two have helped create a caring community. Besides inciting laughter, they have also raised awareness about many important community issues. They were behind the start of Wham Bam Thank You Mammogram Breast Cancer Awareness and Crane's Critters Humane Society. Their tireless efforts in supporting local charities such as Children's First and All Faiths Food Bank are a tribute to their commitment to the area. They show respect by always saying, "We have the smartest listeners in the world." Their show has been the top-rated morning show for years, and in May 2000, they were honored with "Morning Crew Day" by the Sarasota County Commissioners. Pictured here are Christina Crane and David Jones. (Courtesy of Amy Elder.)

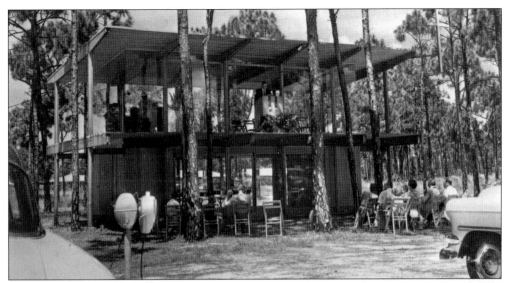

During the 1950s, the Venice-Nokomis Presbyterian Church offered a drive-in service. Rev. Robert White had reservations about this style of church but noticed that it was convenient for a few reasons: for those who could not walk into church, for people who were hard of hearing, and for those who did not like traditional services. The church was designed by architect Victor Lundy from the Sarasota School of Architecture. (Courtesy of the Sarasota County History Center.)

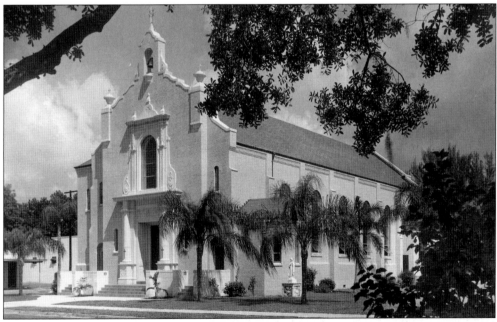

St. Martha's Catholic Church was named after Martha Burns, mother of Owen Burns. She donated the land for the church in 1911. In the late 1930s, several of the circus families attended church and helped raise money for a new sanctuary by performing on the site. In 1940, a new church was built on Orange Avenue and Fruitville Road. The Red Sox also contributed during spring training, and carpenters donated their skills and time. After paying off the church, they started working on building a school. Today St. Martha's has a private school and a special-education program. (Courtesy of the Sarasota County History Center, George I. "Pete" Esthus Collection.)

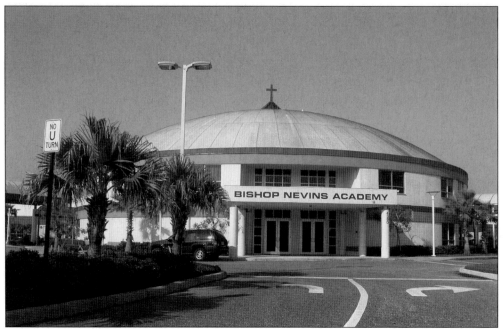

St. Martha's Schools have evolved into Bishop Nevins Academy and Dreams are for Free, which provides education to children with learning disabilities. They are both located on McIntosh Road. (Courtesy of Amy Elder.)

Bethlehem Baptist Church was built in 1899, but the church was started a few years before. Louis Colson donated the land, and the church was built on Mango Avenue and Thirteenth Street (now Central and Seventh Streets). This was the second church built in Sarasota and the first African American church. Colson was the first minister for the Bethlehem Baptist Church and served for 15 years. Due to the growing congregation, the church purchased land on Eighteenth Street and dedicated a new building in 1973. (Courtesy of Amy Elder.)

The First Congregational United Church of Christ (UCC) was started in the Woman's Club (now Florida Studio Theater) in 1954. The church purchased five acres on Euclid Avenue, and charter member Roland Sellew designed the sanctuary, which was dedicated in 1956. Throughout the years, as membership in the church members grew, so did the community outreach activities. The church was instrumental in starting New College, a retirement home called Plymouth Harbor (located on John Ringling Boulevard), and a 40-unit handicapped housing facility called Orchard Place. The church has also participated in Habitat for Humanity. Here is a picture of the Women's Fellowship 2005 board. Pictured from left to right are Sue Metcalf, Millie Small, Nancy Morris, Jacci Tutt, and Barbara O'Connor (president). (Courtesy of Amy Elder.)

Rev. John Syster is the current minister of the First Congregational United Church of Christ and has worked there for over 22 years. Reverend Syster enjoyed celebrating the church's 50th anniversary in the fall of 2004. Over the years, Syster has not only seen but helped to make changes in Sarasota. Pictured here is retired church pastor Rev. John Thompson (at left) with Rev. John Syster. (Courtesy of Amy Elder.)

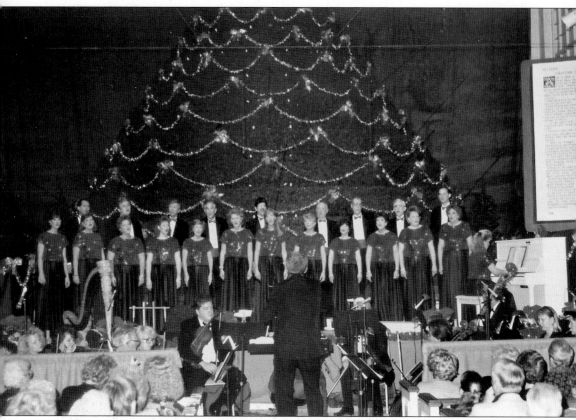

For 31 years, the First Baptist Church, located at 1661 Main Street, has been celebrating an annual "singing Christmas tree" during the holiday season. Over 130 singers, young and old, get together and sing Christmas carols. Pictured here forming the tree is a chorus of singers who are being directed, along with the orchestra, by Pastor Dan Cracchiola. (Courtesy of Arky Nelson and Bobbi Morgan.)

The First Methodist Church, located on South Pineapple Avenue, has gone through many changes over the past 114 years. The congregation was formally organized in 1891. Over the years, there have been several buildings to house the growing church community. The latest building was designed by architects Gary Boyle and Nathan Grant from Tampa. (Courtesy of the Sarasota County History Center.)

Until 1945, the Mennonite and Amish community did not have a permanent site for worship. In 1945, a group of Mennonites organized a committee to build a church. Five lots along Bay Shore Road were donated. Community volunteers, church members, and the Civil Public Service Camp in Mulberry, Florida, provided the labor to build the first Mennonite Church. Pictured here is one of the area's Mennonite churches. (Courtesy of the Sarasota History Center, Hy Dales Collection.)

Temple Emanu-El is located at 151 South McIntosh Road in Sarasota. The congregation follows the practices of the Reform Movement of Judaism. Shabbat services are held every Friday night throughout the year. (Courtesy of Amy Elder.)

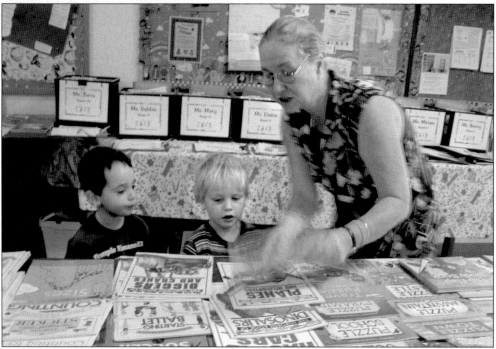

Since 1978, Temple Emanu-El has offered an Early Learning Center for ages 18 months through pre-kindergarten. The center is available to any denomination and is "committed to offering a safe, caring environment where the intellectual, social, and physical needs of the children are met." Pictured here is the school director, Vivian Michelle, reading to two students at a book fair. (Courtesy of Amy Elder.)

Former mayor Fredd Atkins was born and raised in Sarasota. Born on June 19, 1952, Atkins went through the public schools. He attended Booker School from grades 1 through 4, Ocala Howard Academy from grades 5 through 7, Booker Junior High for grades 8 and 9, and finally Sarasota High School for grades 10 through 12. He went into politics because of his love of people. He belongs to the National Black Caucus, the Tiger Bay Club, and the NAACP. Atkins served as mayor from 1987 to 1988 and again from 1991 to 1992. He has served as commissioner from 1985 to 1995 and from 2003 to the present. (Courtesy of Fredd Atkins.)

Katherine Harris (right) was born in Key West. She is a fourth-generation Floridian and was raised in Florida. Her family was very involved in politics and business, and after receiving a master's degree from Harvard, she too worked in the business world. She moved into politics and won a statewide election to become Florida's secretary of state in 1998. This put her in a position to receive nationwide attention in the highly contested Florida recount of 2000. Currently she is a resident here and the U.S. Representative for the 13th district of Florida, which includes Sarasota. Pictured here at a Sarasota election rally is Elizabeth Elder standing with Katherine Harris. (Courtesy of Douglas C. Elder.)

Lillian Burns was born and raised in Sarasota. One of five children born to Owen and Vernona Burns, Lillian attended school in Sarasota. She first attended Miss Pierce School on Palm Avenue, until her teacher left to teach at the Out-Of-Door School (ODA), located on Siesta Key. Burns was the first graduate of ODA. Like her sister Harriet Steiff, Burns left the area for awhile and then returned after retirement. She was dedicated to helping preserve Sarasota's history. (Courtesy of the Sarasota County History Center.)

Diane and George "Pete" Esthus both went to the University of Florida. They each had roots in Sarasota but did not meet until college. George "Pete" Esthus was born in 1929 in Sarasota. Diane was born in Boston, but her great-grandparents had lived in Rye on the Manatee River in the late 1880s, and her parents were married in Bradenton. After college, Diane and Pete moved back to Sarasota in 1956. They have a daughter and son. Over the years, George has turned into a historian, collecting newspaper articles and historical photographs of Sarasota County. His collecting began when his father died in 1965, and he found assorted historical materials, and many people have donated historical items to him. In return, he has donated several materials to the Sarasota History Center. He was the historian for the Cattlemen's Association, the historical society, and the county fairgrounds, and he is the current historian for the Sarasota County Agricultural Fair Association. (Courtesy of Diane and George I. "Pete" Esthus.)

Business owner and realtor Michael Saunders opened her business in 1976. When asked how she continually runs a successful business, she replied that she doesn't recognize failure. "This was not an option for me." She is conservative in her risk taking and doesn't over extend. Saunders's family has been coming to Sarasota since 1933, when her parents acquired land on the north end of Longboat Key. Saunders summered on Longboat Key and learned to drive on Gulf of Mexico Drive. Saunders feels positive about the future of Sarasota. With volunteer organizations such as the Young Professionals Group and Jr. League of Sarasota, Inc., Sarasota has capable young leaders. The county has two planning initiatives that will shape the future. They are the 2050 Plan for land use east of Interstate 75, which was just completed by Glatting Jackson, and the Duany Downtown Master Plan for Sarasota. Even with all of the recent growth, Saunders believes that Sarasota has not lost its sense of community, and that continues to make it a great place to live. Saunders belongs to several community organizations and enjoys being a mentor. (Courtesy of Michael Saunders.)

Lands End cottage was built by Michael Saunders's parents, Frances Fitzgerald (mother's maiden name) and Francis Mayers. The land once belonged to her mother's great-uncle, businessman John Savarese. He purchased the land some time in the early 20th century, and in 1913, he built a house that was later destroyed in a hurricane. His wife gave the land to the Mayers in 1933 (during the Depression) on their wedding day, with the stipulation they would pay off the back taxes. After acquiring the land, they had to chase off a shark fisherman named Sharkie Holbrook, who was squatting on the property. One of Saunders's childhood memories from the cottage is feeling the soft pine needles underfoot that had fallen from the tall Australian pines, which grew together making an archway looking like a cathedral. When the wind blew, they sounded like a symphony. Today the modest and charming cottage is still owned by the Mayers family. (Courtesy of Tom Mayers.)

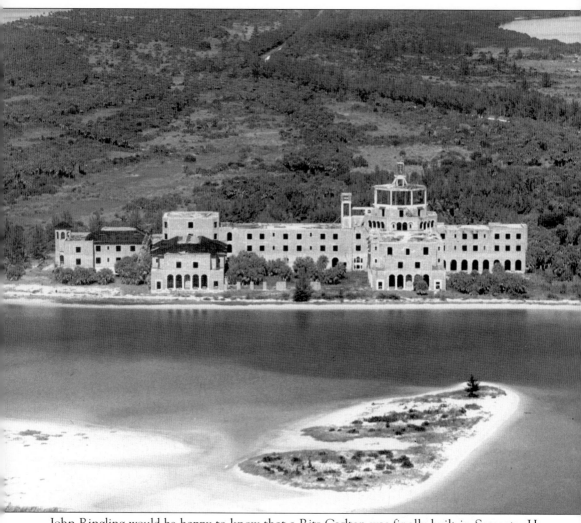

John Ringling would be happy to know that a Ritz-Carlton was finally built in Sarasota. He started building a Ritz on Longboat Key, but when the Depression came, he could not afford to finish the hotel. It was eventually torn down in the early 1960s. (Courtesy of the Sarasota County History Center.)

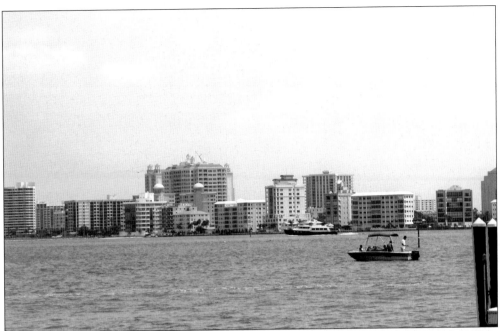

Golden Gate Point continues to be built up with interesting and diverse architecture. Longboat Key, Siesta Key, and Casey Key are well developed. The new Ritz-Carlton appears here in the background. (Courtesy of Amy Elder.)

With land becoming scarcer near the water, one developer built Lakewood Ranch east of Interstate 75 on University Drive. An entire community, including houses, shops, schools, businesses, and even a hospital, has been built over the past decade. This picture shows homes built around Lake Uihlein, which is a man-made lake. This used to be a shell mine, and when all the shell was gone, it was turned into a lake. (Courtesy of Lakewood Ranch Community, Jack Elka Collection.)

Here is an aerial picture of Gulf Gate community, located in the southern part of Sarasota. Gulf Gate was one of the fastest growing developments in the 1960s. They advertised that they were a "total community" complete with housing, business, restaurants, and a branch library. The Gulf Gate Mall was built in 1964 with the Holiday Department Store, Publix Supermarket, and Walgreens Pharmacy. (Courtesy of the Sarasota County History Center.)

In 1921, a large group of citizens worked to raise the money for a hospital. Originally a "tent hospital" was built that housed a temporary, six-bed clinic. As Sarasota grew, so did the need for medical attention. In 1925, a 32-bed hospital opened on Hawthorne Street. At that time, the hospital was operated by the Sarasota County welfare system. Over the years, several improvements have been added. In 1954, Sarasota Municipal Hospital was deeded to the Sarasota County Public Hospital Board. At that time, the name was changed to Sarasota Memorial Hospital to honor the veterans who served in World Wars I and II. Today the hospital offers a state-of-the-art facility and is the only hospital in Sarasota County that delivers babies. In 2000, the hospital celebrated 75 years and named Dr. Finlay as president and chief executive officer. (Courtesy of the Sarasota County History Center.)

Doctors Hospital is also located in Sarasota. It offers a 168-bed acute and general care facility with 24-hour emergency care for both Sarasota and Bradenton. The hospital has a wide range of medical and specialty services including outpatient and rehabilitation. For 38 years, Doctor's Hospital has been developing a more personal approach to healing. It offers over 550 physicians from which to choose. Pictured is the medical building at the Doctors Hospital. (Courtesy of David Keane.)

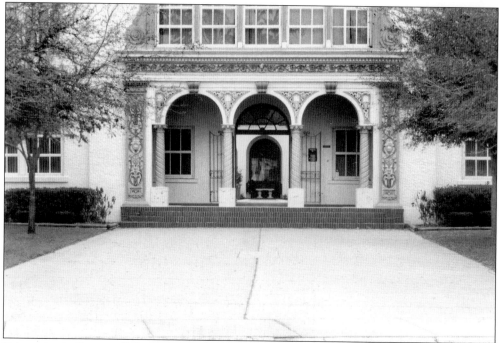

Integration in Sarasota did not go smoothly, and African Americans in the area were not treated well or fairly. Despite the Supreme Court's *Brown v. the Board of Education of Topeka* decision in 1954, Sarasota blacks did not attend white schools until 1962. The NAACP wanted to start integrating, but the Sarasota School Board denied this until the group filed a lawsuit in federal court. In 1962, 29 African American students entered the formerly all-white Bay Haven Elementary School. (Courtesy of the Sarasota County History Center.)

The county wanted to tear down three schools located in Newtown, including Booker High School, during integration. A school boycott was formed under the leadership of John Rivers, a business and community leader. Eventually, the Sarasota School Board decided to keep the Newtown schools and bus white children to them. They were established as magnet schools, and today Booker High and Booker Middle still offer award-winning programs. Pictured here is Booker High School, built in 1952. This was the first modern school built in Newtown. (Courtesy of Amy Elder.)

Lilly Lacey was a pioneer for African Americans in Sarasota. She moved here in 1938 with her husband. While her husband worked as a stiller at the Bee Ridge Turpentine Camp, Lacey worked in celery fields owned by the Palmers and started a laundry business. With no running water, Lacey would have family members pump water from the community well. She would wash and iron clothes using an open fire to heat the irons and palmetto leaves to coat the iron, giving clothes a starched look. During integration, she warned her five grandchildren, whom she was raising after her daughter died, that they may be called names when they attended Riverview High, their local school, but they had to attend. (Courtesy of the Sarasota County History Center, Linda Turner Collection.)

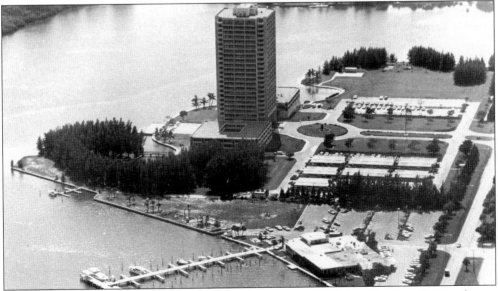

Plymouth Harbor, built in 1966 by the First Congregational UCC, is a 25-story retirement home. Rev. John Whitney McNeil wanted a retirement home that would encourage a sense of community. Designed by architects Frank Folsom Smith and Louis S. Schneider, the building has nine "colonies," each centered around a common area. At the time it was built, the retirement home was the tallest residential building in Florida. Several local competing banks worked together to fund the large mortgage. (Courtesy of the Sarasota County History Center.)

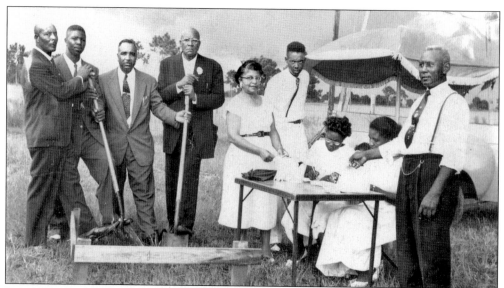

Henry Floyd moved to Sarasota in 1925. He worked in construction and built several community churches and buildings. During World War II, he built a recreation center for African American servicemen in Newtown and taught construction classes at Booker High School. One of the projects for his class was to construct a building on campus. Floyd was president of the PTA at Booker High and worked to get a band started and to purchase instruments for the students. He also is known for his efforts to build a retirement home for African Americans. In 1967, Floyd and Mayor John Betz dedicated the Old Folks Aid Home. In 1982, Sarasota renamed the retirement home after Floyd, calling it J. H. Floyd Sunshine Manor. Floyd belonged to many civic organizations. He is pictured here on the far right. (Courtesy of the Sarasota County History Center.)

The Kiwanis Club raised money for a retirement home for the needy, which was originally called the Sarasota Welfare Home, Inc. (now known as the Pines of Sarasota). Today there are 19 buildings on this 13-acre property. The retirement home is available to people 65 and over who have limited financial resources. The Founders Circle of the Sarasota Garden Club has provided a garden, fish pond, and patio for the facility. A day care was opened in the 1990s for the employees, combining activities with both the elderly and the children to benefit all. Today the Pines receives no government funding and is supported by many local churches and organizations. (Courtesy of Amy Elder.)

Alta Vista Elementary was one of many schools built after World War II. Designed by the architectural firm Sellew and Gremli, the school was built on Euclid Avenue. The 12-room school was supposed to accommodate two classes for each room. The first year, 335 students enrolled. Soon an addition had to be built. Architect Victor Lundy from the Sarasota School of Architecture built the addition, which was described as a "butterfly wing." Today Alta Vista School serves about 700 students. (Courtesy of Amy Elder.)

Brookside School was the first school in Sarasota that combined modern education with modern architecture. Philip Hiss, a member of the Board of Public Instruction (today called the Sarasota School Board) was instrumental in setting forth this modern design. The school was designed by architects Ralph and William Zimmerman, who created a "cluster school" that was intended to create small clusters of classrooms. The architects also designed the building with a large overhang going east to west to create air ventilation. (Courtesy of Laurie Muldowney.)

Six new public schools were developed between 1954 and 1961, and they were built in the international style. One of these schools was Tuttle Elementary School located on Brink Avenue. When the Central Elementary School closed in the 1960s, Tuttle Elementary took half of the overflow. Pictured here is Tuttle Elementary. (Courtesy of the Sarasota County History Center.)

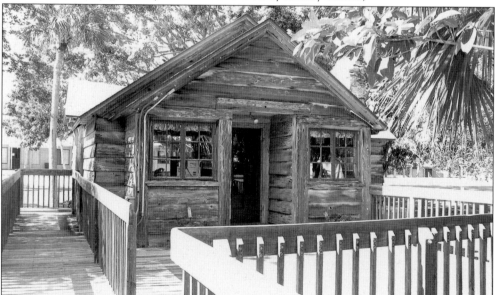

The Out-of-Door School (today called Out-Of-Door Academy) was founded by Fanneal Harrison and Catherine Gavin in 1924 on Siesta Key. The school was based on the theory of Dr. Ovide DeCroly, who was a pioneer of progressive education in Europe. DeCroly believed that a school's function was to promote children's healthy bodies, minds, and spirits and to let students learn in an environment of self-discipline and freedom. Children swam in Big Pass, located on the north end of Siesta Key; learned to speak French; and engaged in construction, including building the library, and the school's table and chairs. Pictured here is the school's old library. (Courtesy of Glendy Huene and the Out-Of-Door Academy.)

112

Today, the Out-Of-Door Academy offers education from kindergarten through high school on two campuses, one on Siesta Key (elementary) and one at Lakewood Ranch (middle and high school). Pictured here is the Lakewood Ranch campus. (Courtesy of Scott Hinkle and the Out-Of-Door Academy.)

Located on 4466 Fruitville Road, Julie Rohr Academy offers a fully accredited school for children from two years old through eighth grade. Julie Rohr McHugh, with her family helping, has run this school since its founding in 1974. McHugh is a talented and loving individual who offers an amazing program for students interested in the performing arts. McHugh also taught a music program called Changing Tides at Sarasota High School. McHugh puts on a Broadway show with her students from Julie Rohr each year with sold-out performances. (Courtesy of Amy Elder.)

Cardinal Mooney High School was founded in 1959. Its emphasis is on developing the whole person—spiritually, emotionally, physically, socially, and academically. It provides students with a Catholic community and offers a quality education with a low teacher-student ratio. Students are required to work 100 community service hours before they can graduate. The school is known for its good sports teams, including its football team called the Cardinal Mooney Cougars. Located on 4171 Fruitville Road, Cardinal Mooney is the only private Catholic high school in Sarasota and Manatee Counties.(Courtesy of Amy Elder.)

Sheriff Ross Boyer worked in Sarasota County from 1952 until 1972. Prior to 1952, he worked on the Florida highway patrol. For 20 years, he helped protect Sarasota. When presidents Eisenhower, Kennedy, Johnson, and Nixon came to the area, he provided security. He was president of the National Sheriffs Association and helped develop the Florida Sheriff's Boys Ranch in 1958. Sheriff Ross Boyer is at far left. (Courtesy of the Sarasota County History Center, Syd Bullington Collection.)

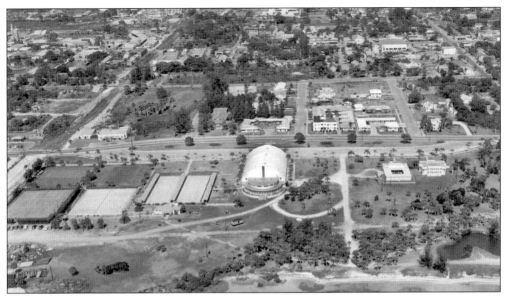

In the 1930s, Mayor Ernest Arthur "E. A." Smith purchased a 37-acre parcel of land downtown. The property had become available when the owner owed back taxes, and the city was able to obtain the land for $15,000. During this time, three buildings were constructed on it. They were the Sarasota Municipal Auditorium, the Sarasota Library, and the Sarasota Art Association. These buildings were designed by Martin Studio between 1939 and 1949. In the 1950s, additional buildings were constructed, including Selby Public Library (now G.WIZ), the Sarasota Garden Club, and symphony hall. (Courtesy of the Sarasota County History Center, Longboat Key Historical Society Collection.)

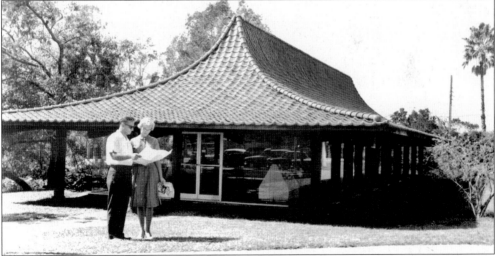

After World War II, a few of the Civic Center's buildings were designed by the Sarasota School of Architecture. The Sarasota Chamber of Commerce (today called Sarasota Convention and Visitors Bureau) was designed by architect Victor Lundy. The building, designed with lots of glass and visible beams to hold up the large roof, looks like a Japanese pagoda. The blue tile roof came from Nagoya, Japan, and was purchased because Lundy wanted the building to blend in with the color of Sarasota Bay. (Courtesy of the Sarasota County History Center, Sarasota Chamber of Commerce Collection.)

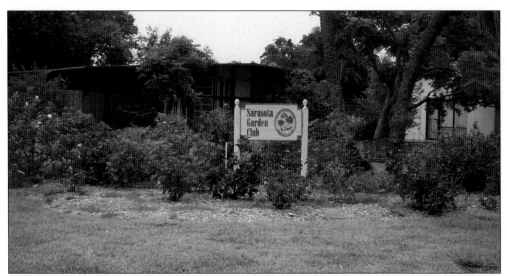

For 30 years, the Sarasota Garden Club went without a home. They improved numerous projects including the Civic Center, which is where they eventually built. In 1955, they were given permission to build behind the Sarasota Chamber of Commerce (today the Sarasota Convention and Visitor Bureau). The Japanese motif was designed by John Crowell from the Sarasota School of Architecture. (Courtesy of Amy Elder.)

Girls Inc. provides after-school and summer activities for Sarasota girls. In 1973, community leaders dedicated the building on Tuttle Avenue to the program. In 1983, a sports complex was added. Director Stephania Feltz is proud of the program that encourages girls to be "strong, smart, and bold." This non-profit national organization offers several age-appropriate programs that help girls from the ages 6 to 18 to become self-confident and responsible. Some of the programs that are offered include Operation Smart, Preventing Adolescent Pregnancy, Media Literacy, and Project Bold. (Courtesy of the Sarasota County History Center.)

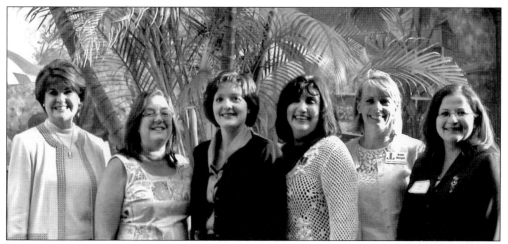

The Junior League of Sarasota raises thousands of dollars each year for community services. The league was started in 1957 with 75 active and sustaining members. Over the years, they have helped several community projects, including Teen Court, Historic Spanish Point, Resurrection House, Newtown Library, Mote Marine, YMCA Youth Shelter, and Career Resource Center in coalition with the Women's Resource Center, to name just a few. Members work hard to raise money through their Barely Blemished Sale, Tour of Homes, Holiday Tour, Gift Mart, and other fund-raisers. The league offers training seminars that often help women members throughout their careers. Pictured here, from left to right, are Elizabeth Wery, Valerie Borr, Anne Toale, Dee Dee Rice, Bobbi Morgan, and Debbie Teven. (Courtesy of Amy Elder.)

The Woman's Resource Center is available for all women within Sarasota County. The center opened in 1979 and has been helping the community for 25 years. This non-profit organization helps over 8,000 of Sarasota County's women each year. Their mission statement is the following: "Women helping women to become emotionally and financially independent." They offer education, support, networking, and referral services to the community. Some people are confused by their name and think they are a rape or other crisis center. This is not their purpose, although they would certainly refer women who are experiencing crisis or transition to the appropriate place. Pictured here is program manager Kelley Schoffield, who is sporting a skirt from the Center's consignment store, Encore and More, located on Main Street. (Courtesy of Amy Elder.)

The Sarasota Family YMCA was founded in 1945 by a group of community leaders. Today, they offer three large facilities located on Fruitville Road, Euclid Avenue, and Potter Park. Their philosophy states: "Build Strong Kids, Build Strong Families and Build Strong Communities." They offer social services, including several children's services, family services, and foster care. Birthday parties and after-school programs are also held at the Sarasota Family YMCA. (Courtesy of Amy Elder.)

In 1979, Brother William Greenen arrived in Florida with the vision of a brighter future for older adults. There are two senior friendship centers in Sarasota County. The Friendship Center is located at 1888 Brother Geenen Way in Sarasota, and the Kathleen K. Catlin Friendship Center is located at 2350 Scenic Drive in Venice. The Sarasota County Friendship Centers' mission states the following: "Realizing that in helping others, we help ourselves, Senior Friendship Centers' Staff, volunteers and participants form a family of 'People Helping People.' " They are a non-profit, charitable organization that dedicates their lives to helping older adults live with dignity and respect. The centers offer services to older members of the community to help them remain independent, relieve loneliness, and improve their quality of life and health. (Courtesy of Amy Elder.)

There are over 40 Red Hat Societies in Sarasota. A group of 20 women from the Bird Key Yacht Club and the Sarasota Yacht Club got together under the leadership of Sally Jaret and started a new Red Hat Society, which they have named "The Red Hat Yachters." They enjoy going to lunch by boat. This picture was taken on April 25, 2005, which is National Red Hat Day, at the Sarasota Yacht Club docks. They are pictured in front of the *Oz*, a 50-foot yacht arriving from lunch at Moore's Restaurant, located on the north end of Longboat Key. Pictured from left to right are the following: (first row) Leslie Perlet, Dee Devlin, Lydia Brummer, Sally Jaret ("Queen Mother"), Marie Rosenblad, and Loretta Turpin; (second row) Betsy Elder, Belle Robinson, Barbara Pryor, Beverly Morse, Jean Hendry, and Mary Quigley. (Courtesy of Marie Rosenblad.)

There are many book clubs located in this cultural county. One club has been meeting since 1995. A group of women who volunteered at the Sarasota Literacy Council formed the Best Book Club. Members have changed, and rules have softened, but people still enjoy discussing interesting fiction, non-fiction, classics, and political books. Members do not always like the books, but they do enjoy the discussion with a little wine and cheese. Celebrating the holidays at Jane Riggins's house in 2004 are, from left to right, Sylvia Nissley, Diane Peterson, author Amy Elder, Lynda Geyer, and Diane Weeghman. (Courtesy of David Keane.)

The Scottish Heritage Society of Sarasota celebrated its 12th Annual Sarasota Scottish Highland Games and Heritage Festival in February 2005. Several clans attended with booths and refreshments. The Campbell tent was located next to the McDonald tent, and the 500-year feud ceased for a few hours. A parade of people dressed in their tartans and marched around the Sarasota Fairgrounds. One man wore a shirt that said, "I lift heavy things," and proved it during the caber toss. Shown here from left to right are Jean Catsakis, Linda Geyer, and Mrs. Howard Hanson from the St. Andrews Society of Sarasota. (Courtesy of Nick Catsakis.)

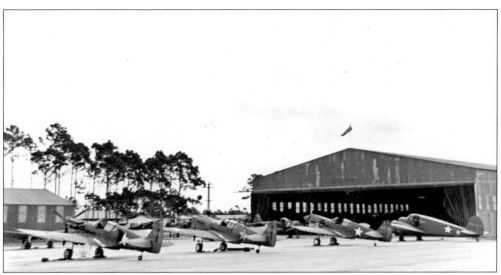

Sarasota County had two military bases during World War II. One was in Venice, and the other was located in Sarasota. The Venice Army Air Base was home to over 5,000 military personnel. The first to arrive was the 37th Service Squadron, 27th Service Group in 1942. The base served as a finishing school for fighter pilots. The soldiers pulled stumps and cleaned up the grass-covered field. Pilots were trained in both air and ground maneuvers and learned how to navigate and fire at targets. The base was closed in 1946. The airfield is now the Venice Municipal Airport. (Courtesy of the Sarasota County History Center.)

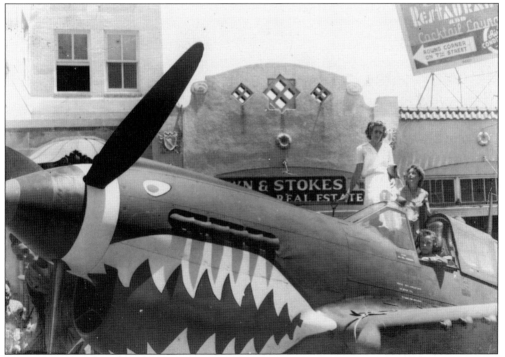

In the 1940s, Sarasotans held bond rallies on Main Street to support the effort in World War II. Here is a picture of a plane on wheels on Main Street, brought in to encourage the public to participate. (Courtesy of the Sarasota County History Center.)

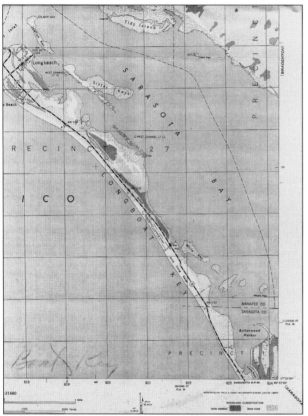

Today's residents of the luxurious homes and condominiums on Longboat Key would be surprised to know that in the 1940s the area was so remote that the beaches were bombing and gunnery-range practice sites. Planes from Sarasota, Venice, and McDill in Tampa practiced on these beaches. (Courtesy of the Sarasota County History Center.)

Here is a target that was used on Longboat Key for practicing gunnery tactics and dive-bombing. (Courtesy of the Sarasota County History Center.)

Four

SPORTS AND RECREATION

Boating is as popular today as it was 50 years ago. Sarasota offers many facilities for boaters to get together with other boaters. In addition to numerous commercial marinas, there are four yacht clubs in Sarasota County and two sailing squadrons. The Sarasota Bay Yachting Association offers several races during the year. Different yacht clubs and sailing squadrons in the area host the races. Pictured here is Jim Liston's J 105 boat in the Sharks Tooth Regatta, which was cohosted by the Venice Sailing Squadron and the Venice Yacht Club. On board are crew Gene Cloud, Rolf Hahn, Bob Jensen, and Chuck Wendt. (Courtesy of Jim Liston, Bob Farrill Collection.)

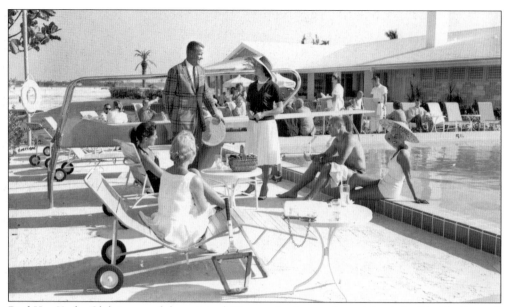

Bird Key Yacht Club is one of the original 13 organizations to have joined the Florida Council of Yacht Clubs. This unique club is located on Bird Key on Sarasota Bay. The club has many talented and interesting members from around the world, and they welcome visitors from other clubs. (Courtesy of the Sarasota County History Center.)

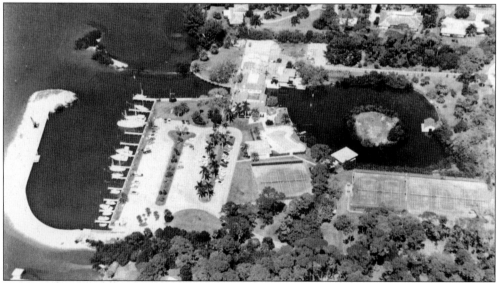

The Field Club was originally built by Mr. and Mrs. Stanley Field as a private estate. Architect David Adler from Chicago designed a beautiful mansion for the Fields when they moved here in the mid-1920s. Stanley Field was Marshall Field's nephew and worked in the family business until retiring to Sarasota. In 1957, Stanley Field put his Sarasota home, located on the Intercoastal Waterway, on the market for a reasonable amount. This price came with the stipulation that a family club would buy the house and entire property without dividing the land for development. After the Sarasota Yacht Club declined the offer, a group of boaters who wanted to start a club organized. They purchased the club for $175,000 and named it the Field Club. (Courtesy of the Sarasota County History Center.)

Sarasota Yacht Club (SYC) was founded in 1926 and is one of the original 13 clubs to join the Florida Council of Yacht Clubs. This large club offers two dining areas, a formal dining room, and the Porthole, where members and visitors can sit inside or outside in a casual atmosphere. The club is conveniently located within walking distance to St. Armand's Circle and is a bike ride to Lido Beach. Pictured here are members and their friends gathering at the Porthole. (Courtesy of Douglas C. Elder.)

The Venice Yacht Club is located off the Intracoastal Waterway in Venice. This fun club offers a large formal dining room, a casual dining room called Pearson's Cove, and a beautiful pool and large tiki bar overlooking the water. The Venice Jetty is located within a short walking distance, and the quaint village of Venice is just a bike trip away. Members and visitors enjoy beautiful sunsets and collect prehistoric shark teeth along the beach. The Venice Yacht Club is also home to a fleet of small sailboats, which provide Venice youth with sailing lessons. Pictured here from left to right are Jack Stevenson (membership committee member), Mike Higel, Pam Davis, Susan Higel, and Janice Stevenson. (Courtesy of Amy Elder.)

The Venice Sailing Squadron (VSS) is an active sailing group that enjoys weekend sails each month. The youngest member of the club is three years old, and the oldest member, Ed Connors, turned 100 in 2004. On Memorial Day weekend, the VSS travels to Burnt Store Marina in Charlotte Harbor, which is no easy feat during tarpon fishing season. Passing through Boca Grande Pass, one must sail carefully through hundreds of fishing boats, avoiding the lines of hopeful fishermen. This is a group picture of the VSS taken at Lido Key during the annual Steak and Sail cruise. (Courtesy of Amy Elder.)

The Sarasota Sailing Squadron is located on City Island and is open to all who want to join for a small fee. It has a clubhouse overlooking beautiful Sarasota Bay. It also has land-based boat storage for trailered boats, docks, and a mooring field for anchoring boats. During hurricane season, many anchored boats from the club have been blown to shore. (Courtesy of Amy Elder.)

The Sarasota Power Squadron (SPS) was organized in 1952. Over the past 50-plus years, their club has grown tremendously. The 1980s was an important decade for the squadron. The SPS purchased a building on Hyde Park Street to provide boating classes to members, and also allowed women to join the squadron. Today the squadron is one of the largest squadrons within the United States Power Squadron, with over 550 members. (Courtesy of Douglas C. Elder.)

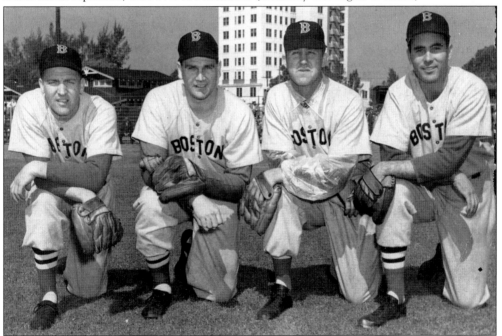

Throughout the years, there have been numerous baseball teams that have come to Sarasota for spring training. The New York Giants, Indianapolis Indians, Boston Red Sox, Los Angeles Dodgers, Chicago White Sox, and the Cincinnati Reds have all played here. Most of the teams played at Payne Park until 1988. Since the spring of 1989, teams have been playing at the Ed Smith Stadium. Here is a picture of the Boston Red Sox at Payne Park. (Courtesy of the Sarasota County History Center.)

In the 1940s and 1950s, Sarasota's beaches became a popular destination. Development along the beaches ensued, and the Lido Casino was built. This provided residents and tourists a place to swim, shop, dine, and dance. In 1950, *National Geographic* magazine ranked Siesta Key as one of the four most beautiful beaches in the world. Fortunately, residents urged the Sarasota Board of County Commissioners to protect the beaches. One of the many beaches acquired for public use was Siesta Key. Here is a picture of people enjoying Siesta Key at sunset while dancing to drums. (Courtesy of Amy Elder.)

The drumming circle on Siesta Key Beach draws community people and visitors. Pictured here is a man dancing on his hands. (Courtesy of Amy Elder.)